THE NEW MOSAICS

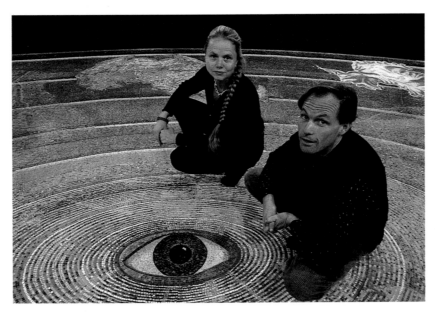

Andrew Ginzel and Kristin Jones, *Oculus*, 1999. Stone, glass, and gold, 80 x 1200 ft. (18 x 198 m). World Trade Center, Chambers Street Subway Station, New York, New York.
Commissioned by The Arts for Transit program of the Metropolitan Transportation Authority. Photo by T. Charles Erickson.

THE NEW MOSAICS

40 PROJECTS TO MAKE WITH GLASS, METAL, PAPER, BEANS, BUTTONS, FELT, FOUND OBJECTS & MORE

D.T. Dawson

LARK BOOKS

A Division of Sterling Publishing Co., Inc.
New York

ACKNOWLEDGEMENTS

Like a mosaic, a book comes into being by virtue of many pieces being fitted together. Many thanks to the following people, organizations, and businesses who provided information, props, or otherwise assisted me in preparing this book.

For graciously lending props: (in Asheville, NC) Ivo Ballentine and Preservation Hall, 23 Rankin Ave.; The Natural Home, 36 N. Lexington Ave; Chevron Trading Post and Bead Company, 40 N. Lexington Ave.; Guinevere's Candlemakers, 28 N. Lexington Ave.; Complements To the Chef, 347 Merrimon Ave.; Constance Boutique, 62 Haywood St.; The Hop Ice Cream Shop, 507 Merrimon Ave.; and Perri Ltd. Floral Decor Studio, 65 1/2 N. Lexington Ave.; all the folks at Lark who came up with all manner of items; and last but by no means least, Karla Weis, for letting me borrow her fine aquatic friends, Pumpkin and Soccer the fish, for a day.

For providing information and/or photos: Bud Goldstone, conservation engineer for the Watts Towers and co-author of The Los Angeles Watts Towers, The J. Paul Getty Trust, 1997; Derek Trayler of Essex, England (the Pearlies); Elaine Nichols at the South Carolina State Museum, Columbia, SC (memory jugs); Penny Smith of Art Cars in Cyberspace @ www.artcars.com; the Mitchell Corn Palace in Mitchell, SD; the City of Los Angeles Cultural Affairs Department; Terry Taylor; Dana Irwin for photos of Spanish and Moroccan mosaics; and David Dawson for photos of Gaudi mosaics in Barcelona.

For her dead-on discernment and all-around panache, art director Dana Irwin; for her invaluable help on all aspects of the book's creation from beginning to end (and noteworthy persistence of *joie de vivre* in even those more frustrating moments), Heather Smith, assistant editor; for her keen writing abilities and ability to jump in the middle of things, Catherine Sutherland, assistant editor; for his great photography and sense of humor, Evan Bracken, photographer; and for doing duty as scan-man for umpteen images, Hannes Charen, production assistant.

ART DIRECTOR: Dana Irwin

PRINCIPAL PHOTOGRAPHER: Evan Bracken
(Light Reflections, Hendersonville, NC)

ASSISTANT EDITOR: Heather Smith

ILLUSTRATOR, PRODUCTION ASSISTANT: Hannes Charen

Library of Congress Cataloging-in-Publication Data
Dawson, DT, 1965-
 The new mosaics: 40 projects to make with glass, metal, paper, beans, buttons, felt, found objects & more/ D.T. Dawson.
 p. cm.
 Includes index.
 ISBN 1-57990-226-x
 1. Mosaics--Technique. I. Title
TT910.D35 1999
738.5--dc21
 99-33046
 CIP

10 9 8 7 6 5 4

© 2000, Dawson, DT

Published by Lark Books, a division of
Sterling Publishing Co., Inc.
387 Park Avenue South, New York, N.Y. 10016

Distributed in Canada by Sterling Publishing, c/o Canadian Manda Group, One Atlantic Ave., Suite 105 Toronto, Ontario, Canada M6K 3E7

Distributed in the U.K. by:
Guild of Master Craftsman Publications Ltd.
Castle Place, 166 High Street, Lewes East Sussex, England BN7 1XU
Tel: (+ 44) 1273 477374, Fax: (+ 44) 1273 478606,
Email: pubs@thegmcgroup.com, Web: www.gmcpublications.com

Distributed in Australia by Capricorn Link (Australia) Pty Ltd., P.O. Box 704, Windsor, NSW 2756 Australia

If you have questions or comments about this book, please contact:
Lark Books, 50 College St., Asheville, NC 28801, (828) 253-0467

Printed in China

ISBN 1-57990-226-x

TABLE *of* CONTENTS

I N T R O D U C T I O N

Mosaic\mō-'zā-ik\ n 1: a surface decoration made by inlaying small pieces of variously colored material to form pictures or patterns 2: a picture or design made in mosaic 3: something resembling a mosaic

—Merriam Webster's Collegiate Dictionary,
Tenth Edition

There's something in human nature that compels us to put pieces together to make something whole. We do it every day, in acts as simple and routine as adding a shopping bill's items up to figure out their sum, to those that are more profound, complex, and rewarding—reflecting on our lives and how we live them, looking at parts of ourselves to get a better handle on who we are. There's also something in us that wants our surroundings to be beautiful. We decorate our homes considering the colors, shapes, and textures of furniture and fabrics, and how they go together. In our gardens, we plant certain flowers next to other flowers to create a garden whose overall design gives us satisfaction. We arrange cookies or *hor d'ouevres* on a plate to create an eye-pleasing effect.

No surprise, then, that human beings have been combining these impulses to make mosaics for thousands of years. The rich history of ancient mosaics is a book in and of itself, crossing continents and cultures from more widely known Near Eastern and

ANCIENT

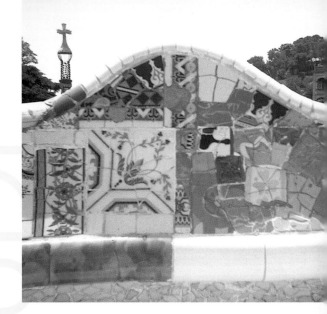

European traditions to those of Central American and New Guinean peoples. A mere outline of the evolving list of materials used to make mosaics spans from pebble mosaics known to have adorned ancient China's formal gardens, through the Romans' evolving practice of the art from the third century B.C to its peak in the Byzantine Era (including the use of stone, glass, and gold tesserae), to myriad applications of mosaics in 15th- through 19th-century Europe.

The 20th century gave birth to new attitudes and approaches to making mosaics, most famously represented by the works of the Spanish architect Antonio Gaudí and a French foundry worker named Raymond Isidore. Gaudí, an architect of revolutionary ideas and talent, is credited with reinventing the application of mosaics; he is widely acknowledged as the first to cover the exterior sur-faces of buildings. Working predominantly in Barcelona, he created numerous buildings and monuments covered with Moorish-influ-enced mosaics made from glazed tiles, discards, and found objects— such as Guell Park, a longtime mecca for mosaicists. Like

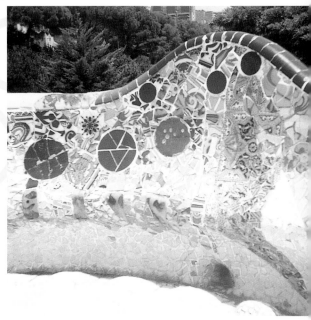

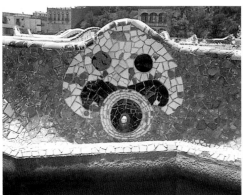

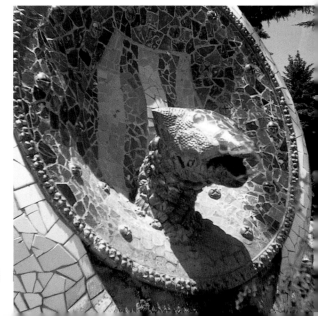

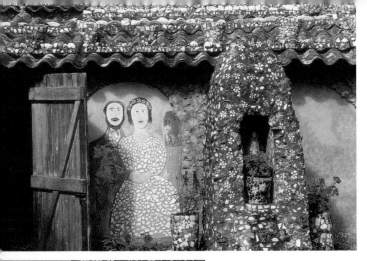

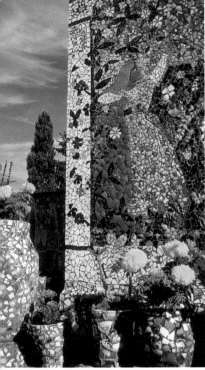

Gaudí, Isidore shifted notions that previously defined mosaics: In 1938, he began a project that would take him 30 years to complete, mosaicking every interior and exterior surface of his house in Chartres, along with a chapel and several garden structures on the property. The style that he used—piecing together fragments of broken dishes and bits of glass—gained its name from the plates he gathered to make his art, and also from his neighbors' disparaging attitude toward him. They called him *Picassiette*, or, loosely translated from the French, "crazy plate stealer." But Isidore persevered, and ultimately the joke was on them. His *Maison Picassiette* is a mecca for mosaicists and art lovers, and *pique assiette* is now the term used to describe a technique adopted by generations of mosaicists worldwide.

Today, both the ancient art of mosaics and the innovative spirits and techniques of artists like Gaudí and Isidore can be seen in creations of artists using many and diverse mediums. Browse through the gallery section of this book, and you'll find gorgeous,

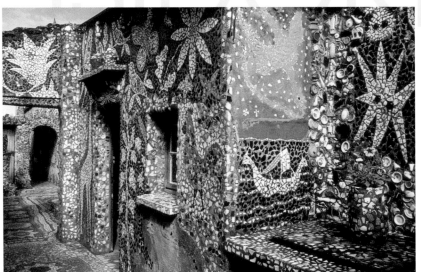

contemporary works made from tile, glass, stone, and other more traditional materials; fresh, witty, and elegant works created with fabric, paper, and metal; and myriad other marvelous examples of how the mosaic form has evolved and expanded.

We've put together *The New Mosaics* to get you in on the fun. Nearly 40 easy-to-make projects incorporating a wide selection of materials and techniques will teach you basic processes for making mosaics using grouting and other conventional techniques, along with how to make beautiful, interesting mosaics from just about any material you choose. Whether you're new to making mosaics, or are well versed in traditional techniques and want to check out fresh approaches and unconventional media, here's loads of inpiration and information to give you new ideas and tweak your creativity towards hours of fun.

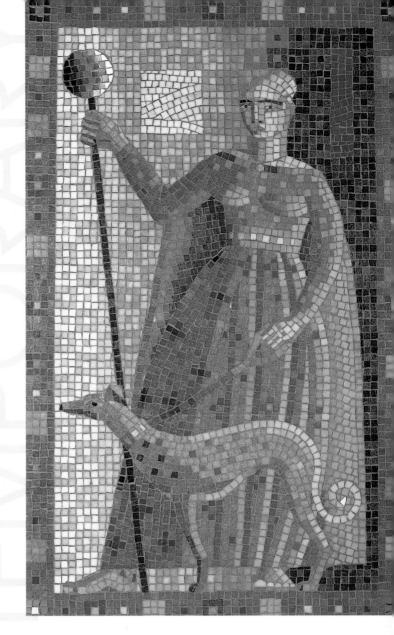

GETTING STARTED

Gathering Materials

TESSERAE

Mosaics claim a unique beauty and hail from an ancient tradition. For centuries, mosaic artists have pieced together small, geometrically shaped pieces of stone, glass, and ceramic—called *tesserae*—to create intriguing designs both pictorial and abstract, indoor and outdoor, big and small. Simply put, tesserae are small pieces used to create a larger design. While the word "tesserae" once referred strictly to traditional mosaic materials, its definition has shifted some with the times. Today, "tesserae" means small units of many types of hard materials—metal, pebbles, the broken crockery of *pique assiette*, to name a few— included in mosaics made by traditional methods.

We've pushed the definition just a tad further. The mosaic projects in this book include many unconventional and traditional "tesserae" attached to objects or backing boards in myriad ways, from fun and utterly simple processes (gluing paper on paper or felt on felt) to more involved and challenging techniques such as traditional grouting methods, and working with stone, glass, ceramic tile, metals, and three-dimensional found objects.

Part of the enjoyment of creating any *objet d'art* is choosing and collecting the materials you need to make it; the span of projects you'll find throughout *The New Mosaics* offers particular opportunity for your imagination and hunter-gatherer skills to roam. You'll find yourself working with paper and polymer clay, stained glass and salvaged metals and stone, marble (and marbles), pretty old crockery and unusual types of ceramic tile, cork and cardboard, eggshells, dried flowers, leather and velvet, and a bevy of beads, buttons, sequins, and more.

None of these materials is hard to find—you may well already have many of the natural materials in your own kitchen cabinets and backyard. (If not, a quick trip to the grocery store, or nursery or garden center will do the trick.) Likewise, the materials you'll need for most projects are readily available at craft or art supply outlets, hardware or home supply stores, office supply or department stores, or good, comprehensive fabric stores.

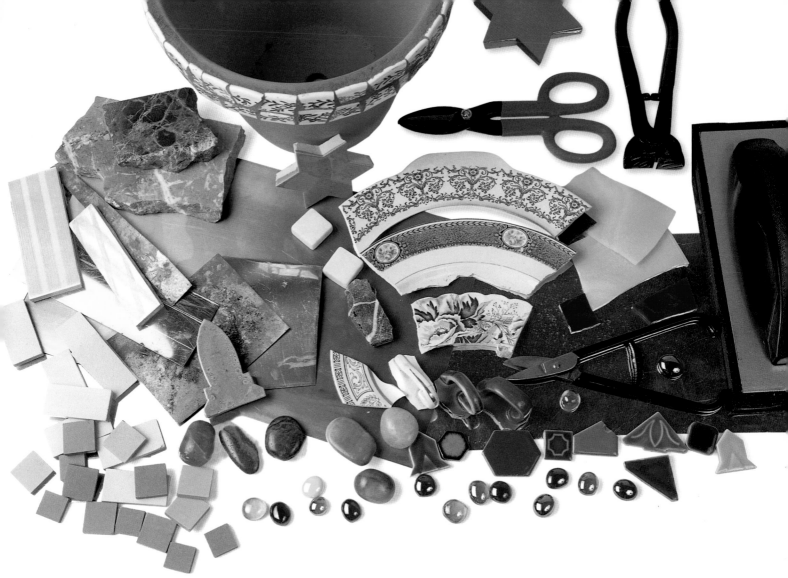

Some projects will take you farther (but not too far) afield in your gathering tasks: Everyone likes a good excuse to take a trip to the ocean, and you may opt to use beach glass picked from shore, rather than the craft store, for the Luminous Glass Candleholder project in chapter 5. Flea markets, thrift stores, and yard sales can often turn up some wonderful finds for *pique assiette* and other projects incorporating bits of old plates, cups, and saucers, miscellaneous baubles, trinkets, and found objects. Here's a little information on some other materials you may not have used before, and where to find them.

Ceramic Tile

Prefabricated ceramic tile and tesserae are available in a tremendous range of colors, shapes, and sizes, with glazed and unglazed surfaces. Some basic types can be purchased from craft outlets and home improvement centers, though the most comprehensive assortments are best found through mosaic supply companies. For projects in this book requiring ceramic tesserae, you'll need unglazed tiles, which come in subtle earth and sometimes pastel tones. They are especially easy

to cut, and are less expensive than other ready-made mosaic materials.

Stained Glass

Translucent and reflective colored glass are well-loved materials among mosaic artists and, like ceramic tiles, come in a staggering spectrum of colors, from pale pastels to bright primaries to iridescent tones of just about any color you can name. Architectural salvage companies are great resources for odd-sized sheets of beautiful old glass. New stained glass can also be purchased in sheets (typically 12 x 12 inches [30 x 30 cm], or cut to size) from both retail and wholesale glass supply companies, and some mosaic supply companies.

Stone And Marble

While it's possible to use just about any type of stone to make mosaics, marble, granite, and slate in shades of black, gray, and white are most commonly used. All of these can be purchased in the form of precut tiles in different sizes, shapes, and thicknesses. You can also purchase slabs of stone used for landscaping and break them up yourself to create tiles or tesserae. If you have some time on your hands, a fun way to collect stone or marble is the *au naturel* route—checking out the wares of a local quarry or finding your own among neighboring hills and dales.

Copper

With imagination and industry, all kinds of metals can be used to create stunning mosaics. You'll need copper for one project—look in scrap metal yards for aged copper that's oxidized, or has acquired through natural processes a greenish tint.

BACKING BOARDS AND THREE-DIMENSIONAL BASES

Traditionally, mosaics are often made on a flat wood surface, then mounted and hung or installed. Only a few of the projects

in this book involve this method, and specific information on the best type of wood to use is listed with each of these projects. Unless you happen to have scrap pieces of the required plywood or other thin woods around the house or garage, check out your local lumberyard or home improvement center for a piece that will do the job.

With a good eye, fate's enthusiasm, and a few hours at a favorite flea market, you can also ferret out wonderful three-dimensional objects on which to create mosaics: from old picture frames and mirrors to used furniture and serving pieces, planters, vases, clocks, boxes, lamp shades, and more. Whatever the object you choose to make your mosaic on, make sure it has a smooth and/or level surface that will comfortably accommodate the design you choose. If you can't find just the right object second-hand, a craft store, department or home supply store, garden

center, gift shop, or unpainted-furniture outlet will provide you with what you need.

ADHESIVES

Once you have tesserae and the backing board or object on which you wish to create your mosaic, you'll need the sticky stuff to attach the tesserae. Most of the projects in the book require either simple craft glue or permanent ceramic tile adhesive. Along with wood glue, cyanoacrylate glue (fast-bonding glue), matte medium, or a strong clear silicone adhesive that you'll need for other projects, both craft glue and tile adhesive can be purchased at home improvement centers and craft stores; tile adhesive can also be bought from mosaic supply companies and other suppliers (such as flooring companies) specializing in ceramic tile.

Permanent tile adhesive comes in a few different forms, some more permanent than others. For projects in this book, you'll need a multipurpose latex-based adhesive, or "mastic." Mastic can be applied with a paintbrush or palette knife (the size will depend on the area you're working on) and, when wet, can be easily wiped from a surface with soap and warm water. Once it has set, it must be removed with a solvent, or scraped off with a palette knife or similar scraping tool.

SPECIALIZED CUTTING TOOLS

Scissors, a craft knife, or your hands will create the tesserae for all projects using soft materials—paper, fabric, clay, and naturals such as cork, eggshells, and flowers. For harder materials—thin copper, stone, glass, and ceramic tile, you'll need the following small, specialized tools:

Tin Snips And Pliers

A pair of aviation-style tin snips or shears for cutting straight lines will work well for cutting thin sheets or pieces of copper. A pair of needle-nose or small pliers will come in handy to bend stubborn areas and ease the cuts.

Tile Nippers

Cuts for all projects in this book involving ceramic or glass tile and stone can be made with a standard pair of tile nippers, which easily cut thin pieces of these harder materials into square, round, and irregular shapes. Tile nippers come in a variety of models sold in hardware and home improvement stores as well as through mosaic suppliers. Look for a pair with spring-action handles and carbide cutting edges, and test them out a little before making your purchase to ensure a comfortable fit in your hand.

Glass Cutters And Running Pliers

Though some types of stained glass can be cut with tile nippers, it's best to be on the safe side and use a small glass cutter. A glass cutter is a stick-shaped tool with a small metal wheel at one end and a metal ball at the other. The metal wheel scores the glass, allowing it to be broken along the score; held the other way round, you can tap the tool's metal ball on glass on the underside of the score to encourage the break.

If you're cutting many small pieces from a large sheet of glass, you may want to use running pliers to first cut multiple strips from which to cut smaller tesserae. Running pliers have one concave and one convex jaw; when placed directly at the score line and squeezed together, the jaws can carry a break a good way. You can also use narrow-jawed pliers to grip the glass as you cut the strips into small, tesserae-sized pieces.

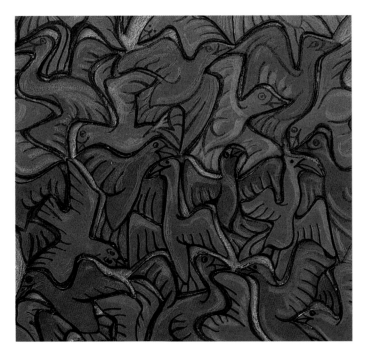

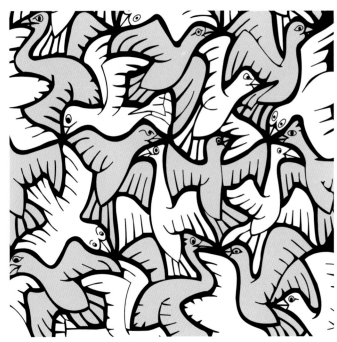

CREATING AND TRANSFERRING
MOSAIC DESIGNS

As the projects and inspirational photographs throughout this book show, mosaic designs can be simple or complex, include recognizable or abstract images and patterns, have alluring antique or ultracontemporary looks, and be traditional or marvelously unconventional. Most of the designs for projects in this book are simple, and you'll find design templates for the few trickier ones in the back of the book. But you may want to use different techniques you'll discover in the following chapters to create a mosaic of your own design. If so, here are some tips:

• If you're just starting, keep it simple! Designs including clearly delineated, largish circles, semicircles, and geometric shapes are easier to work with when you're new to making mosaics. If you've purchased tesserae first, bear in mind their sizes and colors as you devise your design. Choose a design that will complement or echo the shape and contours of the surface on which you're creating the mosaic.

• To find ideas for designs, look through books on ancient mosaics for inspiration and consider shapes and patterns in nature (suns, moons, stars, and fish are images often used in mosaics) and textiles; leaf through old and new magazines for interesting or striking images, or simplify a favorite photograph or painting; elaborate upon a simple symbol or image you find pleasing; or peruse clip-art and stencil books for motifs that will work for you. Designs including a central motif, distinct background, and border can be especially attractive. You can also create unique abstract patterns or images, letting the shapes and colors of tesserae guide you in composing an overall design.

Mix the grout with water to form a smooth, thickish mixture.

Spread the grout over your mosaic surface, filling all spaces between tesserae.

• In pencil, sketch a small, rough version of your design on scrap paper before making an actual template. When you're happy with the results, create the to-size version in pencil, using rulers, compasses, and other guides, then go over the design with a felt-tipped marker. If you're working on a flat surface, it's helpful to trace the outside perimeter of the surface onto a piece of paper, then create the to-size design within its lines.

• For smaller projects such as those included in this book, carbon paper and a pencil or pen are all you need to transfer designs from paper to the surface on which you'll create the mosaic. You can simply place a sheet of carbon paper on the backing board or other surface, center the to-size design over it, temporarily secure the two to the surface with tape, and trace the design. Depending on the material of the surface you're working with, pen or pencil may work better—do a little test trace in a corner to be sure the design is transferring properly.

Grouting

Several projects in this book use tesserae of traditional or unusual materials in tandem with the traditional mosaic grouting technique. Once tesserae have been adhered to a surface, grout is spread over the tesserae to fill crevices between pieces. (The tesserae are then wiped clean of excess grout.) The grout contributes both to the structural integrity and visual interest of the piece.

Grout is available in two basic forms: nonsanded, for filling spaces up to ⅛ inch (3 mm) or so wide; and sanded, for larger spaces between tesserae or for use with dense-bodied materials. (You'll use nonsanded grout for most projects in this book.) Both types can be purchased in a spectrum of light to dark colors; manufacturer's instructions should give grout-to-water ratios for mixing. Opinions differ as to optimal grout-mixing methods: Some mosaicists advocate slowly adding the grout powder to water; some swear by pouring out the grout, creating a small well in its center, and slowly pouring water into the well to mix. Either way, the resulting mixture should have a thick, smooth, consistency that's more dry than wet (like toothpaste, cake frosting, or mashed potatoes, depending on your metaphorical leanings).

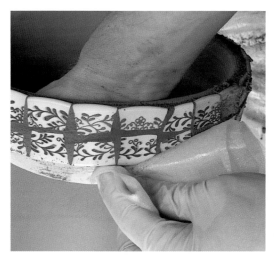

Wipe excess grout away from the surface of all tesserae.

A number of different tools may be used to spread grout, including both square trowels, palette knives, and small spatulas. When spreading grout, it's important to remember to grout only a small area at a time, and to apply the grout as evenly as possible so that it's uniformly level between and with the tesserae. With experience, you'll discover which tools work best for you. To grout the projects in the following chapters, you won't need more than the following:

Float

Floats have the same basic shape as trowels, but a thick, "squeegee"-like rubber surface replaces a trowel's thin metal blade. They're inexpensive and available in a range of sizes (you'll need small and/or medium floats) anywhere you can buy most tools.

Polyethylene Foam

Scraps of this soft packing material work wonderfully for grouting curved surfaces, such as on a pitcher or vase.

Instructions accompanying each project lead you through the grouting process, but here are a few pointers to help you on your way:

Basic Setup

In addition to keeping on hand some basic items such as pencils, pens, sheets of scrap paper, tape, thumbtacks, and any tools you discover are useful for placing or positioning your tesserae, you'll need a suitable work space and all the right stuff to clean up.

A firm, flat surface, whether floor or tabletop, is a must—spread old newspapers to minimize messes caused by grout mishaps. Keep an old bucket, water and soap, an all-purpose solvent (tile cleaner from a hardware store will do the trick for most adhesives), and sponges and rags around to wipe away excess grout and remove dried adhesive from improperly placed tesserae. An assortment of plastic containers and knives will come in handy for mixing batches of grout.

SAFETY ITEMS

Wear safety glasses and (whenever possible) thick work gloves when you're cutting ceramic tile, metal, glass, or stone. Even a tiny airborne shard of any one of these hard materials can cause injury, so work carefully and make sure you're well protected.

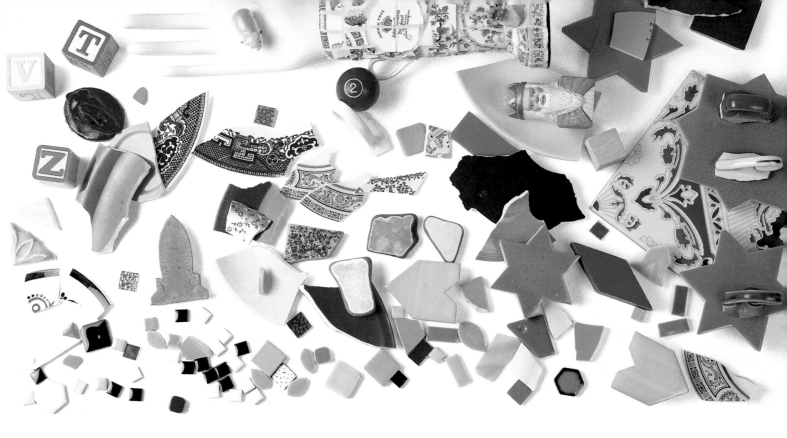

 CHAPTER TWO:

TILE,
PIQUE ASSIETTE,
& FOUND OBJECTS

Ceramic tesserae, shards from pottery and crockery, and all manner of everyday objects that are

pleasing or provocative can be used to make mosaics that give tradition a little tweak. Meander through the pages in this chapter and

you'll find a selection of intriguing combinations of tried-and-true mosaic materials and techniques ... from a delightfully quirky planter

and pitcher to a gorgeous *pique assiette* tabletop, from business card holders that take the *blah* out of the office to a game table that

puts fun back into even the most boring board game. (To appease the gods of convention, we've thrown in one fantastic

traditional project, too.)

CUSTOM
BUSINESS CARD HOLDERS

DESIGNER: MICHELLE PETNO

▲▲▲▲▲▲▲▲▲▲▲▲▲▲▲▲▲▲▲▲▲▲▲▲▲▲▲▲▲▲▲▲▲▲▲▲▲▲▲

Business card holders can be particularly uninteresting objects. But muster your ingenuity and scavenging skills, and—as this wonderful retro-camera model shows—you can turn that notion right on its head. While these fantastic, funky holders might look tricky to put together, they're actually easy (and loads of fun) to make. Using the basic techniques in the following instructions, you can make an infinite variety of one-of-a-kind business holders whose shape and decoration are customized for you or a friend.

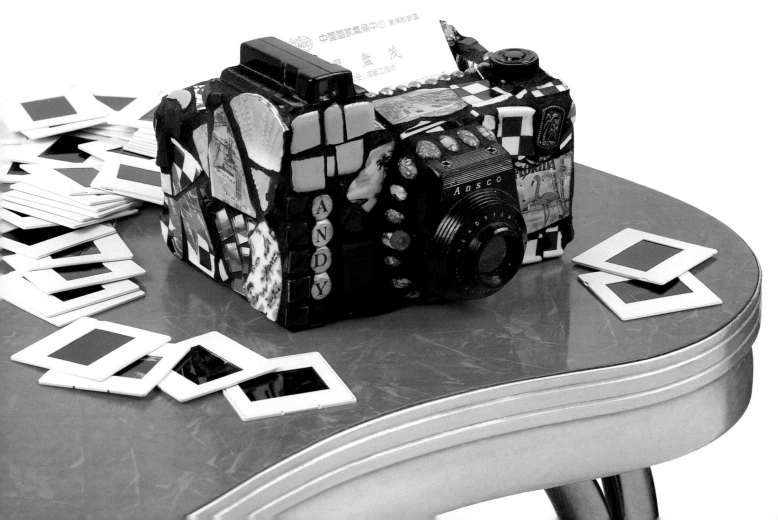

What You Need

Used or vintage lightweight plastic black camera*

1 block styrofoam, 6½ x 4 x 4 inches (16.3 x 10 x 10 cm)*

1 scrap ¾-inch-thick (1.9 cm) styrofoam, at least 3½ x 2 (8.8 x 5 cm) inches

Foil tape

Strong clear silicone adhesive

Assorted used or vintage ceramic plates or saucers (patterned and solid)

A handful each of: ½-inch-square (1.3 cm) mirrored glass tiles; ½-inch-square (1.3 cm) or smaller solid-colored ceramic tiles; loose faux pearls; small pieces of rhinestone or other costume jewelry and decorative trinkets; ½-inch-long (1.3-cm) oblong decorative pebbles or gemstones

1 cup (224 g) black grout (unmixed)

Ruler

Pencil

Latex gloves

Plastic container for mixing grout

Plastic knife or palette knife for mixing grout

Polyethylene foam (optional)

Craft knife

Safety glasses

NOTE: *The camera model used by this designer has a 1-inch-diameter (2.5 cm) lens with 2 inch (5 cm) circular surround on a 2½ x 1 x ½ inch (6.3 x 2.5 x 1.3 cm) base shaped like an upside-down horseshoe; a ¾-inch-diameter (1.9 -cm) knob; and the viewfinder's base is 2½ x 1½ inches (6.3 x 2.5 x 1.3 cm). Information in the following instructions is specific to parts of these dimensions. If you're using parts of different dimensions, you'll need to adapt the materials and instructions accordingly. Since the carved styrofoam block must proprtionally accommodate the camera parts' dimensions, purchase the camera first, then the styrofoam.*

The constructions of cameras differ depending on the brand and model of the camera, and the year it was made. If you have trouble removing parts from the camera, consult a photographers' manual, or ask a camera-shop worker for advice.

What You Do

1

Remove the lens and its base, viewfinder and its base, and a small knob or button from the camera. Set these aside.

2

Place the styrofoam block on a work surface with the 4 inch (10 cm) sides at top and bottom. On the face-up side, measure 1 inch (2.5 cm) in from the left or right at top and bottom. Use a ruler and pencil to mark a line lengthwise between them, and carefully cut along this line. You should now have one piece of styrofoam 6½ x 4 x 3 inches (16.3 x 10 x 7.5 cm), and another 6½ x 4 x 1 inches (16.3 x 10 x 2.5 cm). Set the smaller piece aside for now.

3

For now, select the larger piece and determine which 6½ x 4 inch (16.3 x 10 cm) side will be the top and bottom of the business card holder. (If there is a more level side, use this for the bottom.) With a ruler and pencil or felt marker, measure and mark a rectangle 4 x 1¾ inches (10 x 4.4 cm) on the top side of the styrofoam; center the rectangle approximately ¾ inches (1.9 cm) from the top's back edge and 1½ inches (3.8 cm) from the front; 1¾ inches (4.4 cm) from the left-hand top edge, and ½ inch (1.3 cm) from the right. Use a craft knife to carefully cut along this outline, and begin to remove the styrofoam inside it. Do not carve deeper than ¼ inch (6 mm) or so at a time. Using the rectangle's perimeter as a guide, carve the shape of the rectangle approximately 1 inch (2.5 cm) deep. Discard all excavated styrofoam. This space will hold the business cards.

4

Select the 1-inch-thick (2.5-cm) smaller piece of styrofoam you set aside in step 2; from it, cut a rectangle 2 x 1½ inches (5 x 3.8 cm). Discard leftover styrofoam.

5

Tear strips of foil tape 4 or so inches (10 cm) long and cover the large and small styrofoam forms, overlapping strips and smoothing them against the foam as you go to create as even a surface

as possible. You may need to cut smaller pieces for the small styrofoam form and the larger one's concave rectangle.

6

Next, attach the taped styrofoam component to the base form with adhesive and foil tape. Apply a thin, even layer of adhesive to the back of the smaller piece, position it perpendicular to the top of the base form and flush with the front left-hand corner, and attach it. Attach another layer of foil tape along the joints to secure the attachment. The pieces must be very firmly adhered.

7

Next, use strong silicone adhesive to attach the camera's viewfinder, knob, and lens. Attach the viewfinder parallel with and on top of the small rectangular styrofoam form you glued to the top of the base form. To attach the knob and lens, press the parts into the styrofoam until they make slight indentations, then apply an even layer of adhesive to the backs of the camera parts, and attach them to the styrofoam base.

8

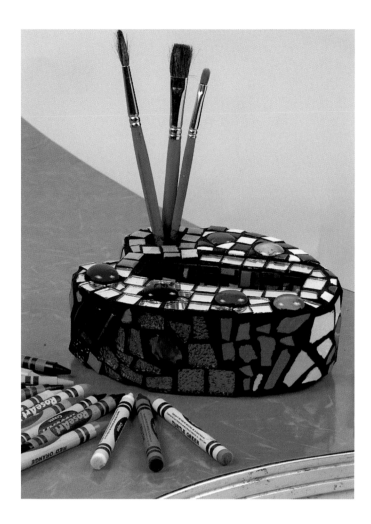

Considering the colors and textures of the plates you've chosen and the shapes of any pieces of jewelry or personalized trinkets you may want to include in the mosaic, create a design or pattern for the mosaic. Break plates into random pieces or, if you prefer a more controlled design, use tile nippers to cut small pieces (no bigger than 1 ½ inches [3.8 cm] long.) Working with a piece at a time, apply a thin, even layer of adhesive to the back of all pieces making up the mosaic and attach them to the foil-covered form. Cover the convex rectangle's interior surfaces with ½-inch-square (1.3 cm) pieces of glass mirror tile positioned flush with one another and the edges of the space.

9

Mix grout according to the manufacturer's instructions; it should be about the consistency of cake frosting or mashed potatoes. Wearing gloves, use your hands or a small piece of packing foam to scoop and spread grout into the small spaces between the shards of tile until the entire surface is well covered. Allow the grout to set for 15 or so minutes, then use pieces of foam to wipe the surface clean, removing all

excess grout on or between tiles. Let the grouted mosaic set for 30 minutes, then use a damp cloth or sponge with water to remove all traces of excess grout. Allow the finished piece to set for 24 to 48 hours before using it.

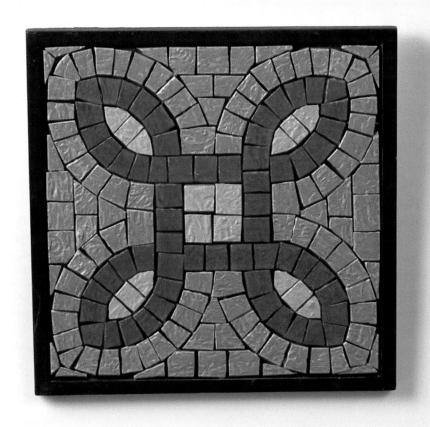

ORNAMENTAL PLAQUE

DESIGNER: SVEN WARNER

▲▲▲▲▲▲▲▲▲▲▲▲▲▲▲▲▲▲▲▲▲

This project uses a unique "double indirect" method that's fun and easy to learn, and can be used to make mosaics from myriad materials and in many scales. The finished plaque's simple design is based on an ancient symbol celebrating the four directions ...its play of rich colors makes it a delight to display on a wall or even propped on a tabletop or shelf.

What You Need

Acrylic paint, black or dark gray

1 cast-plaster ceramic trivet frame with raised edge and ⅜ inch (9 mm) well

or ⁷⁄₁₆-inch-thick (1.1 cm) wood backing board, 7½ inches (18.8 cm) square

1 sheet white paper, 8½ x 11 inches (21.3 x 27.5 cm)

2 wood boards, ⁷⁄₁₆ inch (1.1 cm) thick and 12 inches (30 cm) square

Clear tape

2 pieces clear self-sticking vinyl or shelf paper, each 7½ inches (18.8 cm) square

Colored cast-plaster tile, ½ inch (1.3 cm) wide and ⅜-inch (9 mm) thick: 6 square inches (15 cm) medium gold; 3 square inches (7.5 cm) bright gold; and 3 square inches (7.5 cm) red

Craft glue

Craft knife, scissors, or tile nippers

Paintbrush (small)

NOTE: *This designer used cast-plaster tile he makes himself (see page 127), but you can substitute ceramic or other flat tile in a hard material to make this project.*

What You Do

1

Apply one coat of black or dark gray paint to the trivet or wood backing board. Allow it to dry thoroughly.

2

Enlarge to 400% by photocopying the design below and cut it out. Square and place the design on a 12-inch-square (30 cm) wood board; tape the paper design to the board around the edges. Square and place a sheet of clear self-sticking vinyl paper sticky side up on the paper design.

3

Using tile nippers or scissors (scissors will work only for these plaster tiles), cut the tile into geometric shapes to fill in the design—red for the symbol, bright gold for its interior spaces, and medium gold for the background.

4

When the mosaic design is complete, remove the tape you attached in step 2. Square and place another sheet of clear self-sticking vinyl, this time sticky side down, over the mosaic. Place a 12-inch-square (30cm) wood board on top of the whole thing, and carefully flip the construction over. Remove the top board, and carefully peel the contact paper off at a sharp, low angle.

5

Apply a thin, even layer of glue to the trivet or backing board. Square the trivet or backing board with the glued side down on top of the assembled mosaic. Carefully flip the whole construction over. Remove the board on top immediately. If the mosaic needs any adjusting, use your fingers to gently move the contact paper around and reorient pieces of tile.

6

After 10 or 15 minutes, carefully remove the contact paper. Let the mosaic set for an hour or two before hanging it.

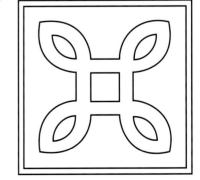

SOUTHWESTERN TERRA-COTTA PLANTER

DESIGNER: TERRY TAYLOR

Here's a new and easy twist on the tried-and-true terra-cotta planter. With a few plates, teacups, and not much else, you can turn a plain old pot into a uniquely decorative container for growing best-loved flora. It also makes a great mosaic project for beginners.

What You Need

Terra-cotta planter, 9½ x 7½ inches (23.8 x 18.8 cm) with a 1-¾-inch (4.4 cm) rim surface

6 or 7 matching ceramic cups with handles and matching rimmed plates (light and bright yellow, orange, dark red, white, and dark green)

Ceramic tile adhesive

¾ cup (168 g) brown grout (unmixed)

Safety glasses

Tile nippers

Foil tray

Pencil

Ruler

Masking tape

Plastic container for mixing grout

Plastic knife or palette for mixing grout

Latex gloves

Polyethylene foam

Sponge or cloth

What You Do

1

Start by separating the plates' rims from their flat bottoms with tile nippers. Make the initial cut by gripping the plate's edge with the tip of the nippers and squeezing the handles together—a large chunk of the rim will break off from the plate. Continue around the plate until the rim is completely removed. Set the plate bottoms aside.

2

From the rims, cut small, roughly rectangular pieces approximately ½ x 1 inches (1.3 x 2.5 cm), with the plate's smooth outer rim running the length of each piece. Set these aside in a foil tray. You'll use these pieces along the top and bottom of the planter's rim.

3

Next, remove the handles from the cups. Grip the edge of the cup's rim with the nippers and carefully squeeze the handles together—this should break the cup cleanly in half. Carefully work your way toward the handle, cutting and removing small bits at a time. The last remaining piece should be the handle still attached to a rectangular or oblong shard.

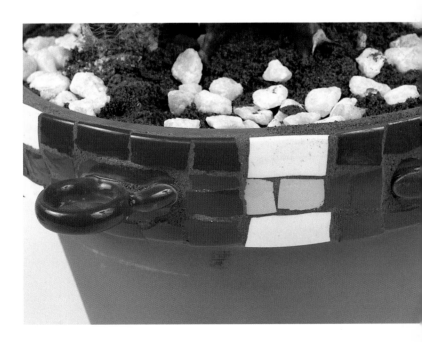

4

On one section of the surface of the planter's rim, measure down about $\frac{1}{2}$ inch (1.3 cm) or so from the top and up $\frac{1}{2}$ inch from the bottom, and make light pencil marks. These marks form a rough guide for positioning your first handle. Select a handle, and position it. You will need space for a piece of plate rim above and below the handle; trim the tile backing the handle a bit if you need to. When you're satisfied with its size, butter the back of the piece with adhesive and attach it. Temporarily secure the handle to the planter with masking tape while its setting. Using this method, position and attach the remaining handles with roughly consistent spacing around the rim; those shown are $3\frac{1}{2}$ to 4 inches (8.8 to 10 cm) apart. Remember to alternate colors. Let them dry for eight hours, then remove all masking tape.

5

Select the smooth-edged rectangles set aside in step 2. Aligning the pieces' smooth edges with the top and bottom edges of the planter's rim, position and attach these first above and below handles. (Note: All pieces should be positioned approximately $\frac{1}{16}$ inch [1.5 mm] apart.) Work your way around the upper and lower edges of the rim until each has a continuous row of edge pieces around the pot. Fill in the remaining spaces with pieces cut to fit from the plate bottoms. Match the color of pieces to the handle they surround, and flank and attach even numbers of pieces on each side of a handle to give the design a symmetrical look. Let the finished mosaic dry overnight.

6

Before grouting, mask the top edge of the planter's rim, the top inside surface, and the external surface below the rim, to protect these areas. Mix grout according to the manufacturer's instructions; it should be about the consistency of cake frosting or mashed potatoes. Wearing gloves, use your hands or a small piece of packing foam to scoop and spread grout into the small spaces between shards of tile until the entire surface is well covered. Allow the grout to set for 15 or so minutes, then use pieces of foam to wipe the surface clean, removing all excess grout on or between tiles. Let the grouted mosaic set for 30 minutes, then use a damp cloth or sponge with water to remove all traces of excess grout.

PIQUE ASSIETTE TABLETOP

DESIGNER: TERRY TAYLOR

▲▲▲▲▲▲▲▲▲▲▲▲▲▲▲▲▲▲▲▲▲▲▲

This delightful little table with its breezy pastels and floral motif makes a great place for setting out a fragrant flower arrangement or pretty lamp, or for serving refreshments. Perfect for a sunroom, it enhances any setting with a nice, light decorative touch.

What You Need

Wood table or piano bench, 13 x 21 x 18 inches (32.5 x 52.5 x 45 cm)

Sandpaper

2 $\frac{1}{4}$-inch-thick (6 mm) basswood strips, each 1 x 21 inches (2.5 x 52.5 cm)

2 $\frac{1}{4}$-inch-thick (6mm) basswood strips, each 1 x 13 inches (2.5 x 32.5 cm)

Wood glue

Assorted ceramic plates and saucers: 3 with floral-patterned bottoms that match or complement each other—1 with $3\frac{3}{4}$-inch-diameter (9.4 cm) bottom; 2 with $3\frac{1}{2}$-inch-diameter (8.8 cm) bottoms; several in three different solid pastel colors that complement those of the floral patterns

Masking tape

$\frac{3}{4}$ cup (168 g) white grout (unmixed)

1 qt. (950 mL) pastel-colored matte or semigloss latex paint

Small handsaw

Small finishing nails

Hammer

Tile nippers

Safety glasses

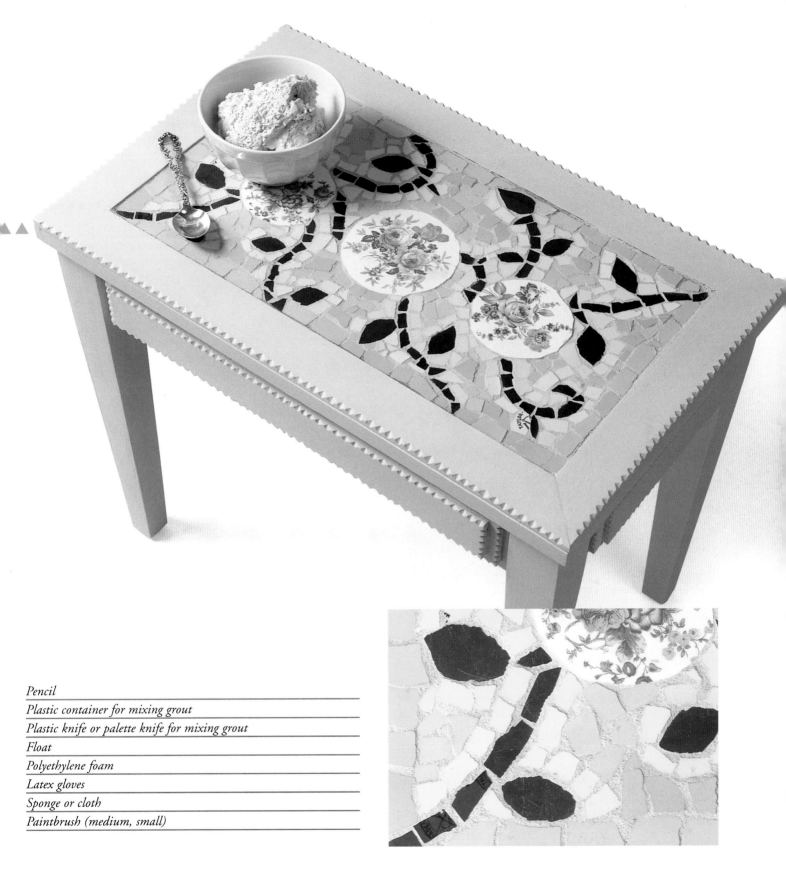

Pencil

Plastic container for mixing grout

Plastic knife or palette knife for mixing grout

Float

Polyethylene foam

Latex gloves

Sponge or cloth

Paintbrush (medium, small)

What You Do

1

Sand all table surfaces to remove any preexisting varnish or finish. With a handsaw, cut each basswood strip to a 45° angle at both ends. Apply a thin, even layer of wood glue to the back of each piece and place them to form a frame around the perimeter of the table surface, flush with its edges. Secure each piece by hammering in a small finishing nail, flush with the wood surface, on each side of the joint at each corner. Allow the glue to dry thoroughly.

2

Separate the plates' rims from their bottoms with tile nippers. Make the initial cut by gripping the plate's edge with the tip of the nippers and squeezing the handles together—a large chunk of the rim will break off from the plate. Continue around the plate until the rim is completely removed. Sort different colors by rim and bottom into piles.

3

On the framed table surface, center and arrange the three patterned plates to find their best positions. When you're satisfied with their placement, apply a thin, even layer of adhesive to the back sides, and attach them to the wood surface. Following the photograph, use the plates as visual center points from which to sketch a leafy vine motif that extends in places from the plate bottoms to the corners and/or edges of the framed surface and "links" adjacent plate bottoms. The vines shown are ½ inch (1.3 cm) wide, with 1½ x ¾ inch (3.8 x 1.9 cm) lemon-shaped leaves.

4

Select the plate or saucer bottoms of the color you wish to use for the vine-and-leaf motif. Cut rectangular pieces smaller than 1 x ½ inch (2.5 x 1.3 cm). Position them end to end and ⅛ inch (3 mm) apart along the vine design you've drawn on the tabletop. When you've found the best arrangement, butter the back of each piece with adhesive and attach it. Carefully cut pieces to match as closely as possible the leaves' dimensions; arrange and attach them.

5

Select the plate or saucer bottoms of the color you wish to use for the outside border of the mosaic. From these, cut rectangles of slightly varying sizes no bigger than 1 x ¾ inches (2.5 x 1.9 cm). Arrange these end to end around the surface perimeter with approximately ⅛ inch (3 mm) space between each piece and away from the wood frame. Glue them in place.

6

With a pencil, mark lines roughly parallel and ½ inch (1.3 cm) outside the vine-and-leaf design on both sides to outline space for a loose border. Select plates to use for the border, and cut small geometric pieces with no side longer than ¾ inches (1.9 cm) to cover the border area. Experiment with different arrangements to find the best placements for pieces within the border space you've created, then attach them.

7

Select the plate bottoms you wish to use to fill in the remaining surface area, and cut pieces of similar sizes and shapes as those you cut for the border. Arrange and attach them on the uncovered surface area in a pleasing pattern to finish the mosaic.

8

Before grouting, mask the wood frame surrounding the mosaic to protect it. Mix grout according to the manufacturer's instructions; it should be about the consistency of cake frosting or mashed potatoes. Wearing gloves, use your hands, a float, or a small piece of packing foam to scoop and spread grout into the small spaces between shards of tile until the entire surface is well covered. Allow the grout to set for 15 or so minutes, then use pieces of foam to wipe the surface clean, removing all excess grout on or between tiles. Let the grouted mosaic set for 30 minutes, then use a damp cloth or sponge with water to remove all traces of excess grout.

9

When the grouted mosaic has dried thoroughly, apply one or two coats of paint to the table. Allow the paint to dry completely after each coat.

KIDS' CHOICE 3-D GAME TABLE

DESIGNER: TAMARA MILLER

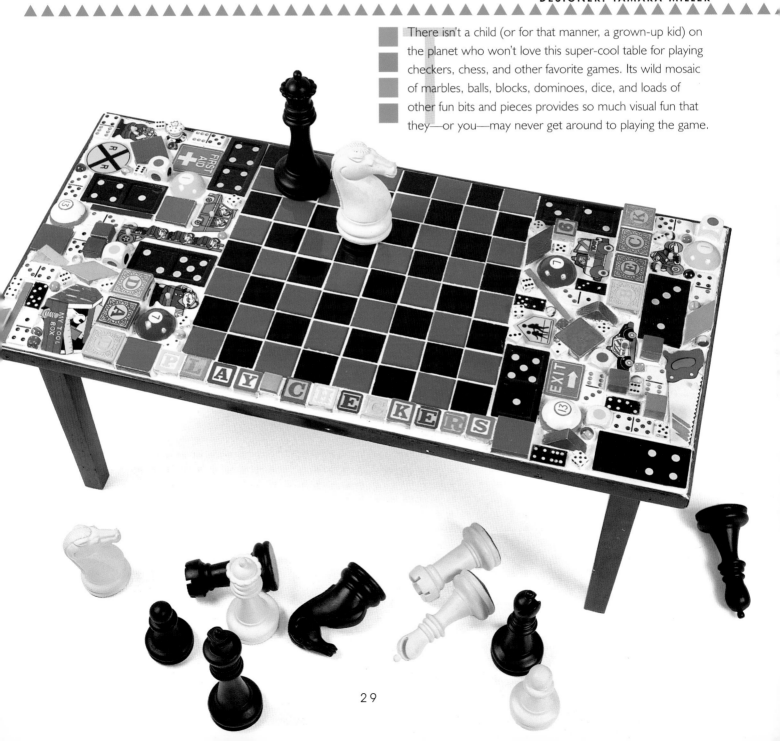

There isn't a child (or for that manner, a grown-up kid) on the planet who won't love this super-cool table for playing checkers, chess, and other favorite games. Its wild mosaic of marbles, balls, blocks, dominoes, dice, and loads of other fun bits and pieces provides so much visual fun that they—or you—may never get around to playing the game.

29

What You Need

Wood table (with raised lip around surface perimeter), 18 x 37 x 16 inches (45 x 92.5 x 40 cm)

64 ceramic tiles, each 2 inches square (5 cm) (32 black, 32 red)

Assorted wood, ceramic, plastic, and glass game pieces and toys of all shapes and sizes, in a variety of colors*

Ceramic tile adhesive

2 cups (448 g) white sanded grout (unmixed)

1 qt. (950 mL) clear acrylic varnish

1 pt. (470 mL) polyurethane varnish (optional)

Pencil

Yardstick

Masking tape

Plastic container for mixing grout

Plastic knife or palette knife for mixing grout

Latex gloves

Polyethylene foam (optional)

Handsaw or jigsaw (optional)

Paintbrushes (medium, small, fine)

NOTE: *This designer used pool balls and marbles; building blocks (some plain, some lettered or numbered) and dice in a range of sizes, shapes and colors; dominoes in different sizes and colors; and bright wood puzzle piece cutouts with child-pleasing motifs. If you're a parent, you may well already have all the makings for your mosaic in the house (or garage or attic. If not, check out flea markets and thrift-store bins to see what you find. If you're using larger objects like pool balls or oversized building blocks, you'll need to cut them in half using a handsaw or jigsaw. Any wood pieces must be sprayed with a nonyellowing polyurethane varnish before attaching and grouting them, to prevent grout absorption into the wood grain.*

What You Do

1

First you'll need to position and attach the 2-inch-square (5 cm) red and black tiles in a checkerboard pattern on the tabletop. This designer chose to position her checkerboard flush with one of the table's long sides to allow room on the other side for a fun row of lettered blocks that reads "Play Checkers." The checkerboard should be 15¾ inches (39.4 cm) square, with red and black tiles alternated 1/16 inch (1.5 mm) apart from one another on all sides to form even rows. Decide whether you want your checkerboard centered or not, and determine its location. To center the checkerboard on a table this size, measure 10½ inches (26.3 cm) in from each 18 inch (45 cm) side and 1⅛ inches (2.8 cm) in from both 37 inch (92.5 cm) sides and mark with a dot the four corner locations where these measurements meet. With a yardstick and pencil, join the four points to form a square.

2

Apply a thin, even layer of adhesive to the checkerboard surface. Select a black tile and attach it flush with one corner of the marked square. Working across one of the players' starting sides, position and attach a row of tiles in alternating colors, 1/16 inch (1.5 mm) apart and flush with the edge of the square (the last one should be red and flush with the corner). Measure and mark 1/16 inch (1.5 mm) from the bottom edge of this row. Starting with a red checker this time, repeat the above process to form a second row of tiles. Continue this pattern to create six more rows, always remembering to start each row with a tile the opposite color of the one above it, until the checkerboard is complete.

3

Based on the game pieces or miscellaneous items you've gathered to use, create a design for the mosaic. Before adhering any pieces to the surface, play with different arrangements of pieces to find the one that's most satisfying. All pieces should be spaced ⅛ to ½ inch (3 mm to 1.3 cm) apart from one another and the table's edge. When you've found a pleasing pattern, apply a thin, even layer of adhesive to the table surface area where one or

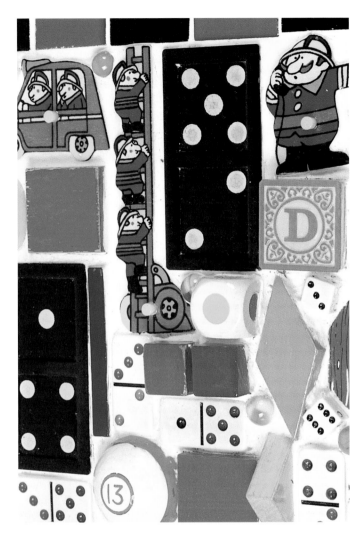

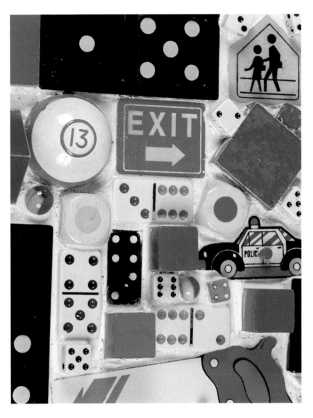

two pieces will be placed and attach them. Let the adhesive set for 24 to 36 hours

8

Before grouting, mask the table's outside edges to protect them. Also mask any objects with recessed areas on the top and/or sides to prevent grout filling crevices. Mix grout according to the manufacturer's instructions; it should be about the consistency of toothpaste. Wearing gloves, use your hands or a small piece of packing foam to scoop and spread grout into the small spaces between pieces until the entire surface is well covered. Allow the grout to set for 15 or so minutes, then use pieces of foam to wipe the surface clean, removing all excess grout on or between pieces. Let the grouted mosaic set for 30 minutes, then use a damp cloth or sponge to remove all final traces of excess grout.

9

When the grouted mosaic has dried thoroughly, carefully apply one or two coats of clear varnish to the mosaic surface. Allow the varnish to dry completely after each coat.

PRETTY-AS-A-PICTURE PITCHER

DESIGNER: TERRY TAYLOR

▲▲▲▲▲▲▲▲▲▲▲▲▲▲▲▲▲▲▲▲▲▲▲▲▲▲

Brimming with fresh-cut flowers or your favorite cool drink, this fanciful pitcher makes a fun and functional addition to any table setting or arrangement. Floral patterns juxtaposed with attached handles give it a pleasing, funky look that works for pitchers of any shape or size.

What You Need

Tall ceramic pitcher—this one's 10½ inches (26.3 cm) tall with a 4½-inch (11.3 cm) diameter from the longest point of the spout

3 ceramic plates or saucers with patterned bottoms and several matching cups and plates in solid colors (for this pitcher, 8 to 10)

Ceramic tile adhesive

¾ cup (168 g) colored grout (unmixed)

Safety glasses

Tile nippers

Foil tray

Fine-tipped permanent marker and/or pencil

Masking tape

Plastic container for mixing grout

Plastic knife or palette knife for mixing grout

Latex gloves

Polyethylene foam

Sponge or cloth

What You Do

1

Start by separating all the plates' rims from their flat bottoms with tile nippers. Make the initial cut by gripping the plate's edge with the tip of the nippers and squeezing the handles together—a large chunk of the rim will break off from the plate. Continue around the plate until the rim is completely removed. Set the plate bottoms aside, with patterned bottoms in a separate pile.

2

From the rims, cut small, roughly ½ inch (1.3 cm) squares and rectangular pieces up to 1 inch (2.5 cm) long. In a foil tray, set aside those with one side formed by the plate rim. You'll use these pieces along the top and bottom edges of the pitcher to give it a finished look.

3

Next, remove the handles from all cups. Grip the edge of the cup's rim with the tip of the nippers and carefully squeeze the handles together—this should break the cup cleanly in half. Carefully work your way toward the handle, cutting and removing small bits at a time. The last remaining piece should be the

handle still attached to a rectangular or oblong shard. Set the handles aside.

4

From the plate's patterned bottoms you set aside in step 1, cut square or rectangular pieces of more or less equal size. On your work surface, arrange the pieces in the pattern's original order with ⅛ inch (3 mm) spaces between them. (They should form a rough circle.) On opposite sides of the pitcher, center and place the pieces in this formation. Apply a thin, even layer of adhesive to the back of each piece and attach it to the surface.

5

Select the handles you set aside in step 3, and experiment with different possible positions for them on the pitcher. (All handles should be attached at least ¾ inches [1.9 cm] from the pitcher's top and bottom, as you'll need space for a piece of plate rim above and below the handle.) When you've settled on a satisfying arrangement, butter the back of each handle piece with adhesive and attach it. Temporarily secure the handles to the pitcher with masking tape while they set. Let them dry for eight hours. Remove all masking tape.

6

Select the pieces you set aside in step 2 and position them ⅛ inch (3 mm) apart in a single row around the pitcher's top and bottom circumference, with the sides formed by smooth plate rim flush with the pitcher's edges. Use tile nippers to cut small geometric pieces from the remaining solid-colored plates and cups, and fill in all of the remaining surface area in a pleasing pattern. Let the finished mosaic dry overnight.

7

Before grouting, mask the top edge of the pitcher's rim and the top inside surface to protect these areas. Mix grout according to the manufacturer's instructions; it should be about the consistency of cake frosting or mashed potatoes. Wearing gloves, use your hands or a small piece of packing foam to scoop and spread grout into the small spaces between shards of tile until the entire surface is well covered. Allow the grout to set for 15 or so minutes, then use pieces of foam to wipe the surface clean, removing all excess grout on or between tiles. Let the grouted mosaic set for 30 minutes, then use a damp cloth or sponge with water to remove all traces of excess grout.

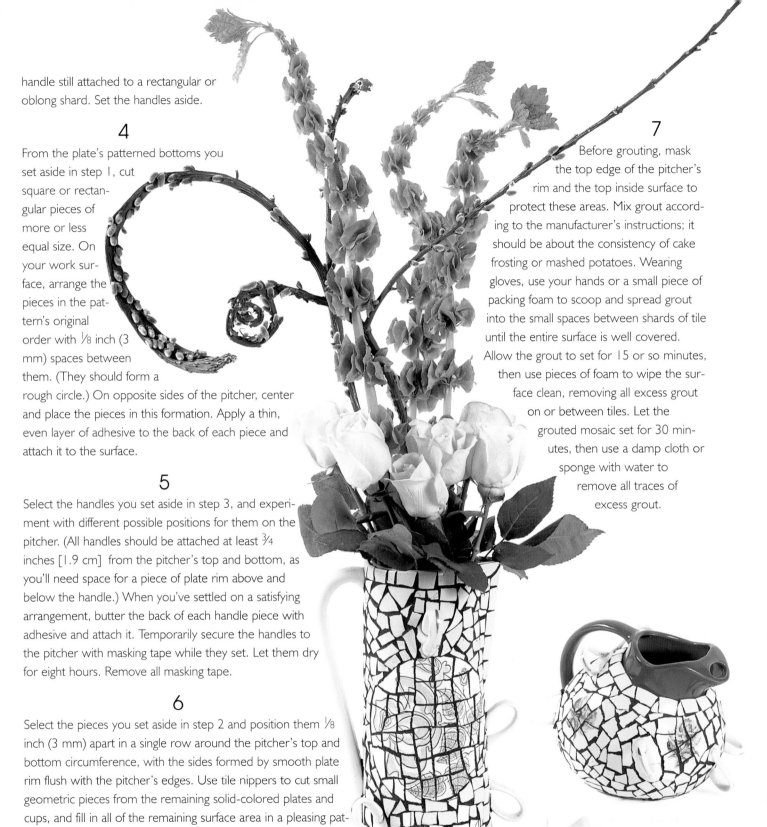

MEDITERRANEAN
MIRROR

DESIGNER: EVANS CARTER

Antique tiles in dusky shades of red, yellow, blue, and green

work together in subtle patterns to make this mirror border look

as though it came straight from a villa in the south of France. It

adds classic mystique to its setting, and makes a great piece to

hang in a foyer or entryway.

What You Need

1 sheet ½-inch-thick (1.3 cm) plywood, 20 inches (50 cm) square

1 mirror tile, 12 inches (30 cm) square

Wood glue

Tracing paper

Carbon paper

Masking tape

¼-inch-thick (6 mm) ceramic tiles (brick red, light blue, light green, and light yellow)

Ceramic tile adhesive

¾ cup (168 g) gray grout (unmixed)

Pencil

Ruler

Felt-tipped marker

Thumbtacks (optional)

Safety glasses

Tile nippers

Plastic container for mixing grout

Plastic knife or palette for mixing grout

Latex gloves

Float

Polyethylene foam (optional)

Sponge or cloth

What You Do

1

Place and center the mirror on the piece of plywood. When you've found its correct position, trace around the mirror. Remove the mirror and apply an even layer of adhesive to its back side. Reposition it, and attach it to the plywood. You'll now have a plywood frame of approximately 4¼ inches (10.6 cm) around the mirror.

2

Place and center a piece of tracing paper over the framed mirror, and use a ruler and pencil to trace the outline of the frame's interior. Cut out the mirror-sized square. Make sure the paper template exactly matches the plywood frame, as the design you'll be drawing on paper must later be transferred onto the plywood. Set the mirror aside for now.

3

Place the paper frame on your work surface. Following the photograph or creating your own mosaic pattern, create a symmetrical design around the frame. *(Note: The brick-red borders along the inner and outer edges of the design shown are 1 inch [2.5 cm]*

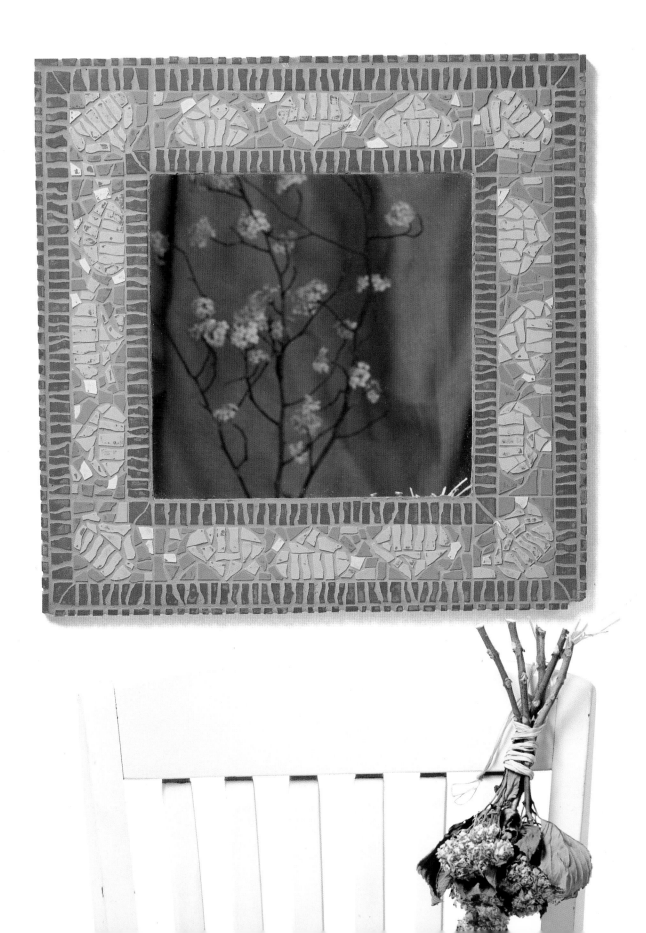

wide; the pale green teardrop-shaped motifs are approximately 2½ x 2 inches [6.25 x 5 cm] and spaced 1 to 2 inches [2.5 to 5 cm] apart.) You can either draw shapes for each mosaic piece, or draw in outlines for borders and motifs. Draw lightly in pencil, erasing to make changes if necessary, until you're pleased with the finished design. Go over all design outlines with a felt-tipped marker. Place the actual mirror on your work surface; over it, place and center a sheet of carbon paper, then the paper frame template. Temporarily secure the two layers of paper to the plywood with masking tape or small thumbtacks in a couple of locations. Use a pencil to trace the design, transferring it onto the plywood. Remove the sheets of paper; discard the carbon.

<div align="center">

4

</div>

Gather your tiles and sort them by color into piles. Determine which colors you wish to use for different parts of the design, assign each color a number, and pencil the numbers on the plywood in appropriate locations. Using tile nippers, cut small pieces to fill in different design sections, remembering that all pieces must be spaced ¼ inch (6 mm) or so apart. When all pieces are cut, arrange but do not yet adhere them on the plywood frame. You may find that you need to slightly change the shape of a piece or two, or cut a few pieces "to order" to fill in odd spaces or corners. When you're satisfied with the arrangement, apply a thin, even layer of adhesive to the back of each piece and attach it to the plywood frame. Extend the design's outside border onto the frame's outside edges with same-sized pieces roughly aligned with those on the border. Let the glued pieces set overnight.

<div align="center">

5

</div>

Before grouting, mask the mirror to protect it. Mix grout according to the manufacturer's instructions; it should be about the consistency of cake frosting or mashed potatoes. Wearing gloves, use your hands and a float or piece of packing foam to scoop and spread grout into the small spaces between shards of tile until the entire surface is well covered . Allow the grout to set for 15 or so minutes, then use a damp sponge or cloth to wipe the surface clean, removing all excess grout on or between tiles. Let the grouted mosaic set for 30 minutes, then use a damp cloth or sponge with water to remove any final traces of excess grout. Allow the grouted mosaic to dry for 24 hours.

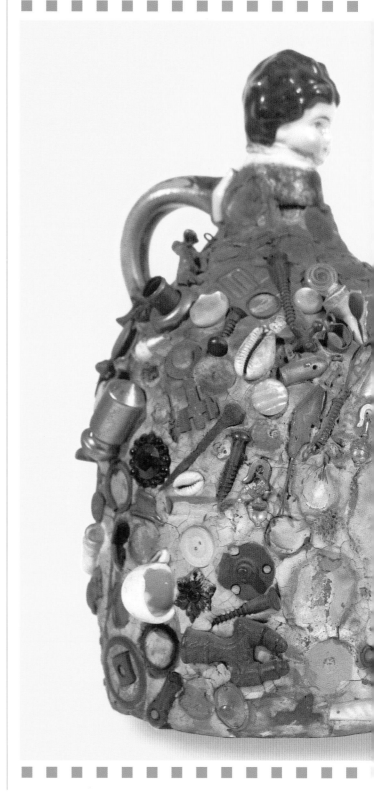

Memory Vessels: Mosaics With Personal Meaning

"*M*emory jugs*" are among the most delightful and interesting mosaics that incorporate both natural and man-made miscellany such as pebbles, seashells, jewelry, trinkets, bric-a-brac, mirrors, toy parts—and just about anything else the maker happens to find, or chooses to use. Popular among Victorian hobbyists, it's widely believed that the first memory jugs evolved out of African-American practices of African funerary traditions. Some West African burial customs, such as those of the Congo region's Bakongo people, included decorating graves with items belonging to the deceased. Upholding this tradition, African-Americans created another—memory jugs, decorated with objects that belonged to or had some relationship to the person who'd passed on.*

Like that of many art forms begun as cultural ritual, the spirit of memory jugs has wound its way into the spirit of contemporary art. Nowadays, the practice of making these beautiful, unusual, and wholly personal pieces is not often linked with the passing on of a loved one. But some artists have given the tradition a twist, creating highly contemporary and individual mosaicked vases, urns, and other vessels, such as the marvelous piece pictured (above, right) by mosaic artist Michelle Petno.

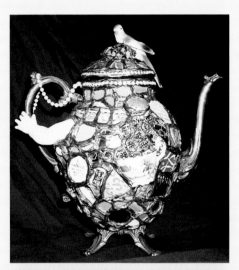

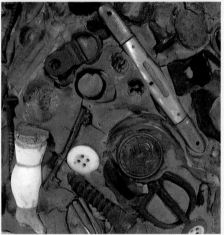

The piece shown on the far left (detail above) is a wonderful example of a traditional memory jug.

PAPER & FABRIC

Change the saying from the old "Rock, Scissors, Paper" game into "Fabric, Scissors, Paper," and you've got nearly all the basic ingredients for this chapter's diverse and inspiring projects. Whether the comforting feel of wool or the lush weave of velvet most appeals to you, whether sophisticated decorative paper or simple corrugated cardboard most piques your creative interest, here are imaginative solutions to fill some of your everyday needs. (Great stuff to whip up for birthdays remembered at the last minute, too.)

This easy-to-make tray's fruit-bright colors and playful design shout out summer fun. With the simplest materials and a few hours, you can create a unique, long-lasting serving piece that's perfect for outdoor entertaining. A tall pitcher of iced lemonade, some good company and music, a balmy afternoon, and the party's set!

What You Need

Wooden tray with serving surface area of 11½ x 18¾ inches (28.8 x 46.9 x cm)*

Acrylic paints (bright green, black, medium-dark and bright purple, bright blue, medium-dark aqua, orange, yellow, red, metallic gold)

1 sheet standard white poster board

Craft glue

1 pt. (470 mL) acrylic clear gloss

1 pt. (470 mL) clear resin (optional)

Paintbrushes (large, medium, fine)

Pencil

Ruler (optional)

Scissors or craft knife

NOTE: *Flea markets, yard sales, and thrift stores may turn up a tray that's perfect for this project, or you may already own one that will work. If not, it's not hard to find standard-sized rectangular trays at craft or home supply outlets. You can also create a tray by using a picture frame with mat and glass as the serving surface, fitted for use with new or antique drawer handles. If you choose to use a bigger, smaller, or differently shaped tray, experiment with different shapes for the paper "tiles"—circular or crescent shapes may better suit a round or octagonal tray, for example.*

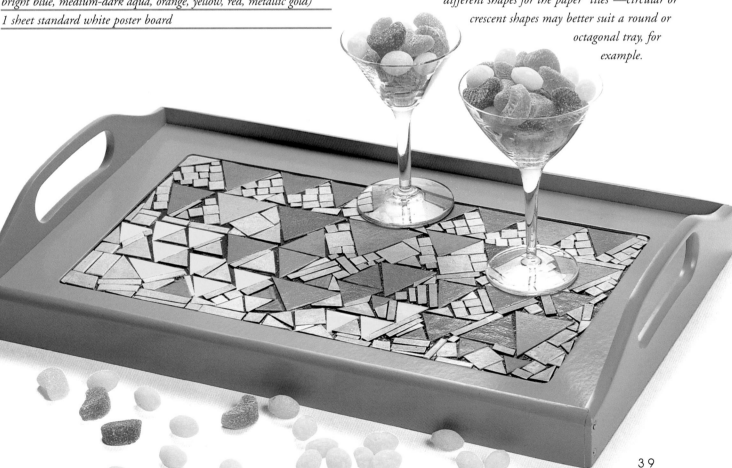

1

Apply a thick, even coat of bright green paint to the whole tray, and set aside to dry.

2

Cut a piece of poster board 8½ x 15¾ inches (21.3 x 39.4 cm) and paint it black. *(Note: For this and other cutting jobs for this project, you can freehand cut the poster board with scissors, or use a ruler and craft knife to cut more precise shapes.)* This will serve as the background of the mosaic design, giving it a grouted look. Set it aside until dry to the touch.

3

From the remaining poster board, cut approximately 45 even-sided triangles ranging in size from ¾ to 2½ inches (1.9 to 6.3 cm) per side. Paint a few of each size bright purple, medium-dark purple, bright blue, medium-dark aqua, orange, yellow, and red. Cut the last of the poster board into 150 to 200 small triangles, squares, and rectangles of various shapes and sizes; paint them metallic gold. These pieces will fill in spaces between the larger colored triangles. Allow all of the painted pieces to dry for a couple of hours.

4

Following the photograph or letting your eye guide you, arrange and glue the brightly colored triangles on the painted black poster board. Apply the glue evenly and gently press the edges of each paper triangle down to secure it. Next, leaving spaces of ¼ inch (6 mm) or less between all pieces, arrange and glue the smaller gold shapes in a mosaic pattern between the triangles, until the surface of the black background is covered. Let the mosaic set until it is completely dry.

5

Apply an even coat of acrylic clear gloss to the construction. When this has dried (again, touch it to test), center the construction on the tray's serving surface—you'll have a painted green border of 1½ inches (3.8 cm) on all four sides. Glue the mosaic in place, and let it set overnight.

6

For extra protection against wear and tear, coat the whole tray or just the finished serving surface with an even layer of clear resin.

FESTIVE FELT
PILLOW

DESIGNER: PAT SAMUELS

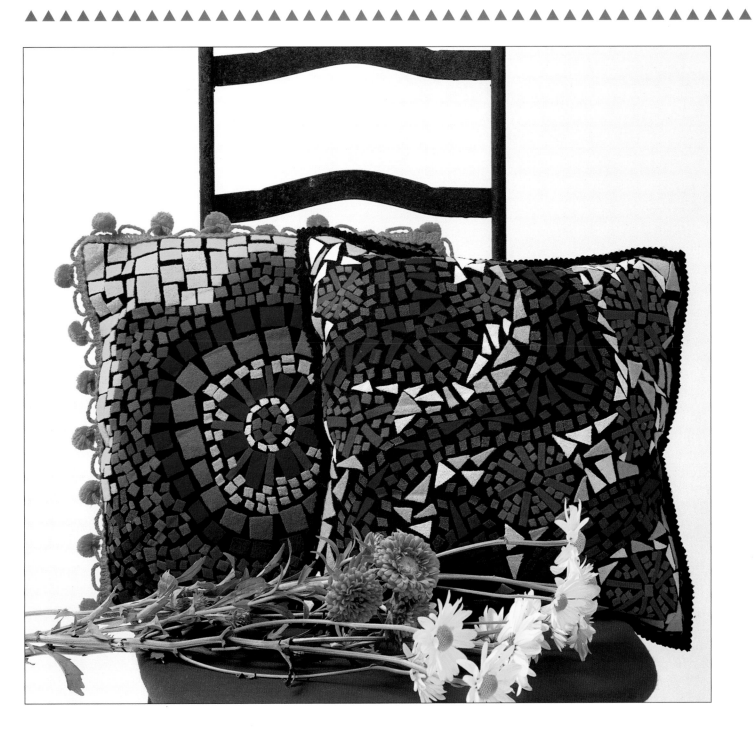

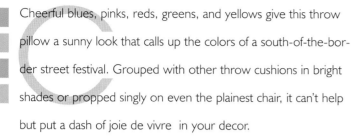

Cheerful blues, pinks, reds, greens, and yellows give this throw pillow a sunny look that calls up the colors of a south-of-the-border street festival. Grouped with other throw cushions in bright shades or propped singly on even the plainest chair, it can't help but put a dash of joie de vivre in your decor.

What You Need

1 yd. (90 cm) of black felt*

Scraps of felt in green, bright pink, red, gold, white, and 3 shades of blue (approximately ½ yard [45 cm] total)*

1 yd. (90 cm) of medium-weight fusible web

1 sheet of white cardboard, 12 x 12 inches (30 x 30 cm)

1 small skein of brightly colored 6-strand embroidery floss

1 small bag of polyester fiberfill

Ruler

Craft scissors (sharp) or pinking shears

Iron

Tracing paper

Black felt-tipped marker

Chalk marking pencil

Embroidery needle with large eye

NOTE: *This designer preshrank colored 100 percent wool garments in hot water, then dried them on a high heat setting in the dryer and pressed them flat with a steam iron, to produce the felt for this pillow. Fabric dyes can also be used to dye scrap white wool. You can use these methods to make your own felt, or purchase 100 percent wool felt from a fabric store.*

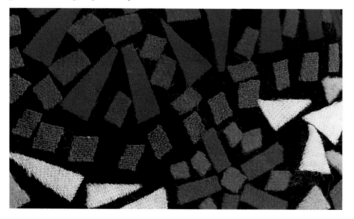

What You Do

1.

Measure and cut two 12 x 12 inch (30 x 30 cm) squares of felt, and set them aside.

2.

Apply fusible web to the back of all scraps of colored felt. Place the web-backed pieces on an ironing board with the felt side up, and run an iron set on high heat over the felt. *(Note: Instructions for using fusible web products vary from manufacturer to manufacturer, so make sure to closely follow the manufacturer's instructions.)* When each piece of fabric has cooled, peel off the fusible web's paper backing.

3.

Following the photographs, create a design for your pillow on a piece of white cardboard. (You can "eyeball" the design shown, or use the following method.) Outline all shapes making up the design with a felt-tipped black marker. Place a sheet of tracing paper over the design and clearly trace all shapes. Carefully cut out the shapes. Transfer your design to one of the cut black felt squares by positioning and tracing around each shape with a chalk pencil.

4.

Cut the fused colored felt into the shapes your design requires and position them adhesive side down on the black felt. When the design is complete, fuse pieces onto the felt (see step 2). Let all pieces cool, then check for any loose pieces. Re-fuse pieces if necessary.

5.

Cut four strips of fusible web 1 inch (2.5 cm) wide and 12 inches (30 cm) long. Fuse these along the edges of the remaining 12 x 12 inch (30 x 30 cm) piece of black felt. Let them cool, and remove the paper backing. Lay the black felt, with mosaic design face up, square on top of the just-fused piece. Fuse three sides together. Fill the pillow with fiberfill, then fuse the remaining side.

6.

Use brightly colored embroidery floss to hand-sew a decorative or running stitch around the edge of the pillow.

FUN-WITH-WORDS SCRAPBOOK

DESIGNER: NICOLE TUGGLE

▲▲▲▲▲▲▲▲▲▲▲▲▲▲▲▲▲▲▲▲▲▲▲▲▲▲▲▲▲▲▲▲

If you have a favorite poem or set of song lyrics, or just love playing with words, here's a project for you. By arranging photocopies of words in interesting typefaces, you can create an infinite number of different designs that are visually arresting and have a nice personal touch. Or create a theme with words and give it as a gift on a special occasion or a friend's favorite holiday.

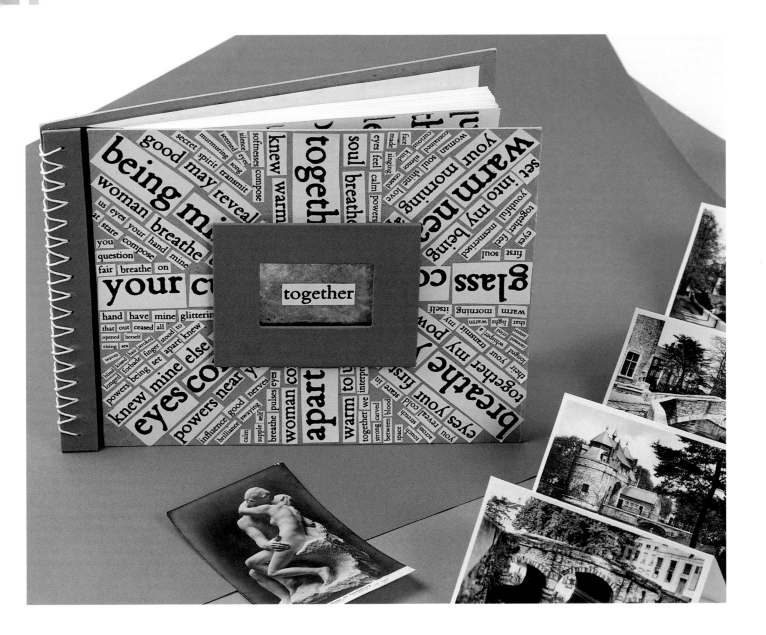

What You Need

2 pieces ³⁄₁₆-inch-thick (5 mm) cardboard or bookbinding board, each 9 x 12 inches (22.5 x 30 cm)

A selection of xeroxed words in a variety of sizes

1 sheet decorative paper

40 or more sheets typing or photocopy paper (for pages), 8½ x 11 inches (21.3 x 27.5 cm)

String, thread, or ribbon

Small piece of mica

Pencil

Craft knife

Scissors

Craft glue

Awl

Large bookbinding or embroidery needle

Glue gun

Matte medium

What You Do

T o M a k e T h e S c r a p b o o k

1

On one of the 9-inch (22.5 cm) sides of a piece of cardboard, measure ⅞ inch (2.2 cm) in and mark with a pencil; cut along the line with a craft knife. Set the ⅞ inch (2.2 cm) strip aside. On the large piece made by the cut, measure in ¼ inch (6 mm) from the 9 inch (22.5 cm) side. Mark and cut it; the larger piece made by this cut will serve as the main section of the scrapbook's front cover. Discard the ¼ inch (6 mm) strip.

2

Select the ⅞ inch (2.2 cm) strip of cardboard you cut in step 1, and cut a piece of decorative paper slightly larger than it. Glue the paper to the strip so that one side is cleanly covered. Fold the excess paper around and over the back of the strip, and glue it in place. This will serve as the front "spine" of the book, through which thread or string will be laced to bind the book to its back cover.

3

Place the scrapbook's front cover upside down on a surface. Place the covered ¼-inch (6 mm) strip upside-down ¼ inch (6 mm) away from one of the cover's 9 inch (22.5 cm) sides. Cut a 9-inch-long (22.5 cm) strip of decorative paper 1 inch (2.5 cm) wide, and glue it to the board. This will act as the "hinge" between the scrapbook's front spine and cover.

5

Turn the construction over, right-side-up with the covered strip, or spine, to the left. Measure ½ inch (1.3 cm) from the top and bottom of the spine, and mark these points. Continue marking the spine at ½ inch (1.3 cm) intervals until there are 17 dots. Poke through each dot with an awl in a screwing motion.

6

Select the remaining 9 x 12 inch (22.5 x 30 cm) piece of cardboard, and place the front cover over it with the sides aligned. Using the puched holes as a guide, mark through to the back cover with a pencil. Punch through all the holes.

7

Make the same vertical marks and measurements for holes on one 8½ inch (21.3 cm) side of all of the sheets of typing paper. Working with 10 or so pages at a time, poke the holes, checking as you go to make sure that holes in all pages match up. Gather the pages together when finished.

8

Clamp the text pages between the covers with all holes aligned. Starting at the back, sew through the bottom hole—leave several inches of thread on the back side. Sew upward around the spine of the book and through the second hole in back (the thread will be coming out the front). Continue the running stitch until the thread comes out the top hole. Wind the thread around the spine, then down through the second to top hole in the back (the thread will be coming out the front). Continue the running stitch downward. Tie the remaining thread in a knot, cutting off the excess.

9

For the frame on the front of the cover, you may use a purchased lightweight 4 x 5 inch (10 x 12.5 cm) frame, or make

your own by wrapping a frame cut from board with decorative paper. Here, a small piece of mica has been glued with a glue gun to the center of the cover, with a selected word then centered and glued on top. Center the frame on the cover with a 2½ inch (6.25 cm) border on all sides, and glue it in place.

To Make The Word-Mosaic

1

Select a passage of text you like. Enlarge the passage to various percentages on a photocopy machine. You might have to experiment a bit to get just the right size. For this book, five different sizes of text are used.

2

Cut out larger words individually. For smaller text, cut out a few words or even a line of text as a single piece. Place the photocopied words and phrases on the scrapbook's cover, experimenting with different arrangements to find the visual effect you like best.

3

Once you've settled on a design, glue the pieces of paper to the cardboard cover with matte medium. Matte medium serves as both an adhesive and a protective coating, without adding too much shine or texture. Allow the book to dry before using it.

get the best

Every one likes them, and you're benefiting all the family in every way imaginable. To get the best dates sold in the best manner ask for

Dromedary the best

Golden Dates

best manner

family Dates

WHITE-ON-WHITE LAMP SHADE

DESIGNER: NICOLE TUGGLE

So simple! Yet this handsome lamp shade's spare design and clean, natural color scheme make it a great accent for any contemporary setting. When the lamp is lit, variations in the textures and colors of paper squares suffuse the room with an interesting, gentle glow.

What You Need

3 sheets lightweight, semitranslucent decorative paper, each 8½ x 11 inches (21.3 x 27.5 cm) (2 sheets cream-colored, 1 sheet ivory)

1 white cloth-covered lamp shade with 4-inch-diameter (10 cm) top and 9½-inch-diameter (23.8 cm) base

Matte medium

Ruler

Scissors

Paintbrush (medium)

What You Do

1

Measure and cut one sheet of cream-colored paper into strips ranging in width from ½ to ¾ inches (1.3 to1.9 cm). Cut the strips into small squares (approximately 107) of roughly equal dimensions. Next, cut 1⅝ inch (4.1 cm) squares of cream- and ivory-colored paper—you'll need approximately 19 of each color. Cut the remaining cream- and ivory-colored paper into approximately 14 rectangles (7 of each color) roughly ¾ x 1½ inches (1.9 x 3.8 cm). Sort all the cut paper shapes into like piles.

2

Use matte medium to attach the paper squares and rectangles to the shade—it will also seal the finished shade. Starting at the shade's top, position and attach the small cream-colored squares flush with the shade's edge, with a ¼ inch (6 mm) space between each square. Brush on a base coat of matte medium around the shade in the area where you're working; place each square individually, then immediately brush matte medium over it to seal it.

3

About ¼ inch (6 mm) below the top row, position and attach larger squares, alternating colors, in a row around the shade. Follow with a row of small squares; then a row of rectangles in alternating colors; another row of small squares; a row of larger squares in alternating colors; and last, a row of small squares around the bottom of the shade and flush with its edge. Make sure to leave ¼ inch (6mm) between each row. (Note: You may have to slightly cut the last piece placed in a row to fit.)

4

Let the shade dry completely before use.

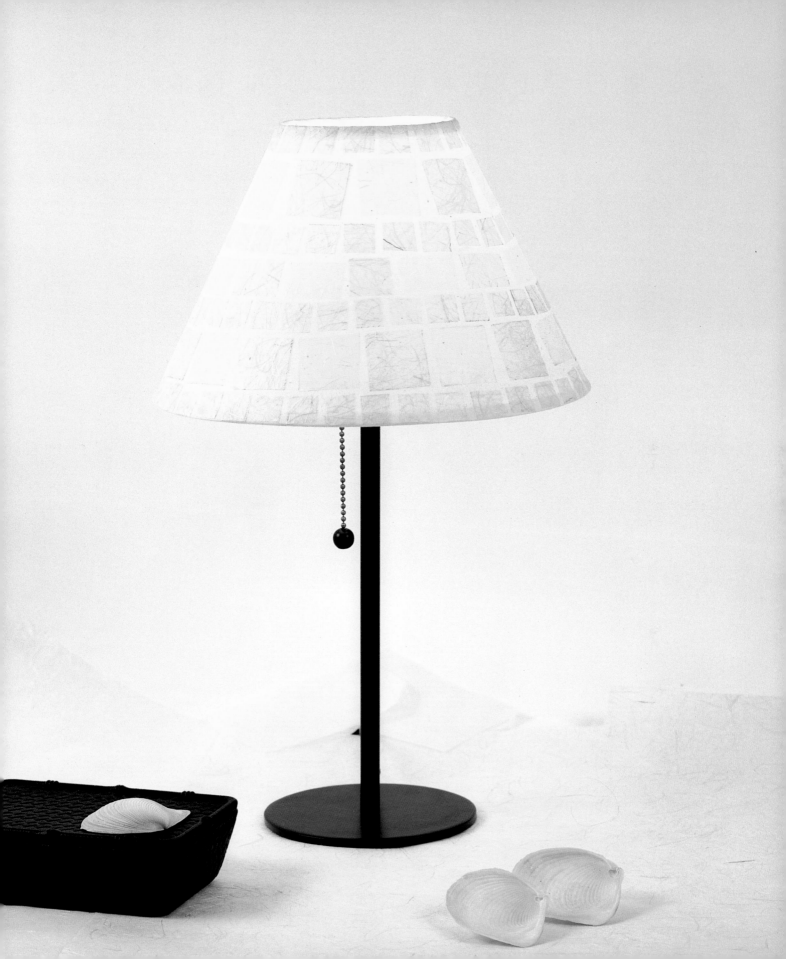

" T R O P I C A L M O N D R I A N "
L E T T E R B O X

DESIGNER: ELLEN ZAHOREC

▲▲▲▲▲▲▲▲▲▲▲▲▲▲▲▲▲▲▲▲▲▲▲▲▲▲▲▲▲▲▲▲▲▲▲▲▲

Add a dash of vibrant, artful whimsy to a desktop or hall table with this delightful (and delightfully inexpensive) letter box. Its patchwork of luscious Carribbean hues brightens up any spot in the house and is sure to take the edge off the paying-the-bills blues.

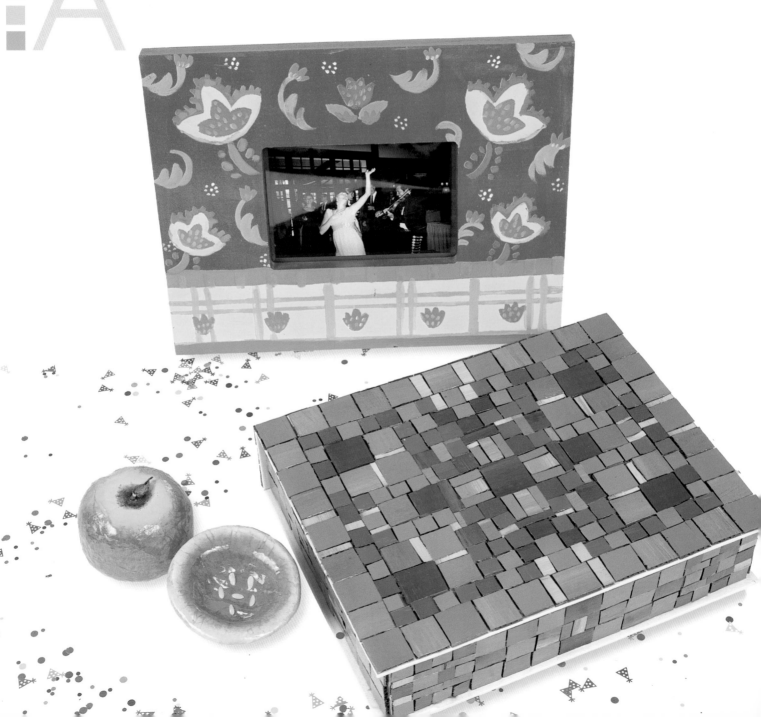

What You Need

1 or 2 sheets of ⅛-inch-thick (3 mm) corrugated cardboard*

Acrylic paints (purple, bright blue, orange, bright and pale orange, bright green, medium and pale aqua)

1 cardboard box 9½ x 12 x 2 inches (23.8 x 30 x 5 cm)

Craft glue

1 pt. acrylic clear gloss

Scissors

Paintbrush (medium)

NOTE: *Collect used corrugated cardboard boxes (your local recycling center's a good source) or purchase sheets of corrugated cardboard from a paper supply store.*

What You Do

1

Cut cardboard into long strips of slightly varied widths approximately 1 inch (2.5 cm) wide and narrower. Paint the noncorrugated side of the strips in different colors. Set them aside until dry to the touch.

2

Cut each strip into squares and rectangles of varying sizes approximately 1 x 1¼ inches (2.5 x 3.1 cm) and smaller. Using the photograph or your own imagination as a guide, arrange the painted pieces of cardboard in a pleasing pattern on the top and sides of the box with small ⅛ to 1/16 inch (3 to 1.5 mm) spaces between pieces. Glue them in place, and let dry overnight.

3

Apply one fairly thin coat of acrylic clear gloss to the surface of the box. When it's dry to the touch, apply a second thin coat. This will give the box a more finished look and help set the cardboard "tiles." Let the second coat of varnish dry completely before using the box.

HOLA! MOLA! PHOTO ALBUM

DESIGNER: HEATHER SMITH

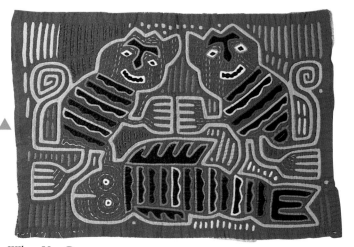

The paper mosaic for this photo album was inspired by the vibrant tones and simple motifs of Costa Rican cloth molas. Using any simple picture or design, bits of colorful scrap paper and glue can turn a plain old album or scrapbook into a charming, one-of-a-kind holder for favorite snapshots or paper memorabilia.

What You Need

1 cardboard-covered photo album or scrapbook, 12¼ x 18¼ inches (30.6 x 45.6 cm)

Mola design

1 or 2 sheets of bright blue decorative paper, 24 x 36 inches (60 x 90 cm)(or enough to cover the album)

1 sheet of bright orange decorative paper, 24 x 36 inches (60 x 90 cm)

Tracing paper

2 sheets of bright blue decorative paper (2 different shades), 7 x 10 inches (17.5 x 25 cm)

Scraps of brightly colored decorative, watercolor, and construction paper (yellow, orange, red, purple, light green, white, and black)

Pencil

Ruler

Scissors

Matte medium or craft glue

Paintbrush (small)

NOTE: *Some handmade papers have a tendency to bleed when wet. Before assembling the design on the album's cover, apply adhesive to a small scrap or two of the decorative paper you've chosen to test it.*

What You Do

1

Wrap the large sheet of bright blue paper around the photo album, creasing the paper around the album's edges and folding excess paper over onto the inside cover. Trim any excess that can't be neatly folded over the album's edges.

2

Spread a thin layer of matte medium or craft glue across the surface of the album cover. Position the bright blue cover paper on the sticky surface. Use your hand to smooth out the paper and press it in place on the cover, and a fingernail to push the paper into creases formed where the cover bends to open. Continue to apply adhesive and smooth the paper around the album. Fold the edges over and glue them in place on the cover's inside. *(Note: From now on, the area you'll be working in is the 11⅛ x 18¼-inch [27.8 x 45.6 cm] surface of the album's cover that excludes the album's binding.)*

3

From the large sheet of orange decorative paper, measure and cut a piece 10¼ x 13½ inches (25.6 x 33.8 cm). Center and position this piece on the album's blue cover, creating a ¼-inch (6 mm) blue border on all sides. Glue it in place.

4

Next, you'll need to transfer the mola design (or other pattern of your choice) onto the orange paper, or second layer of the

cover. If you're using this mola design, you can enlarge to 400% by photocopying the design shown at right, below. Cut out the pattern, then center and position it on top of the cover's orange layer. With a pencil, trace the pattern's outline onto the orange paper

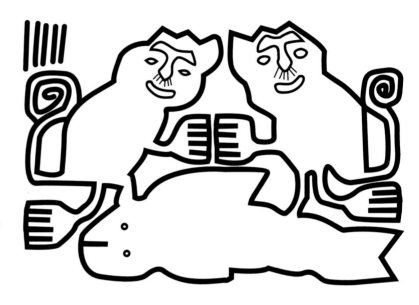

5

Cut the two 7- x 10-inch (17.5 x 25 cm) sheets of bright blue paper into very small geometric shapes approximately ¼ to ½ inches (6 to 1.3 mm) in size. Cut scraps of brightly colored construction paper into similarly sized and shaped pieces (you'll need a few small crescent shapes for the mola's corner designs, the animals' eyes and mouths, and fish scales). Overlapping pieces slightly, arrange these small scrap pieces of paper to "flesh out" the pattern you have traced. (You may need to cut a few smaller or larger pieces as you go, to fill in any gaps.)

6

Working in a small section at a time, clear the paper scraps from the cover and spread a thin layer of matte medium on the album's orange surface. Press the paper scraps back into place, then lightly brush a thin layer of matte medium over the positioned pieces to prevent them from peeling off.

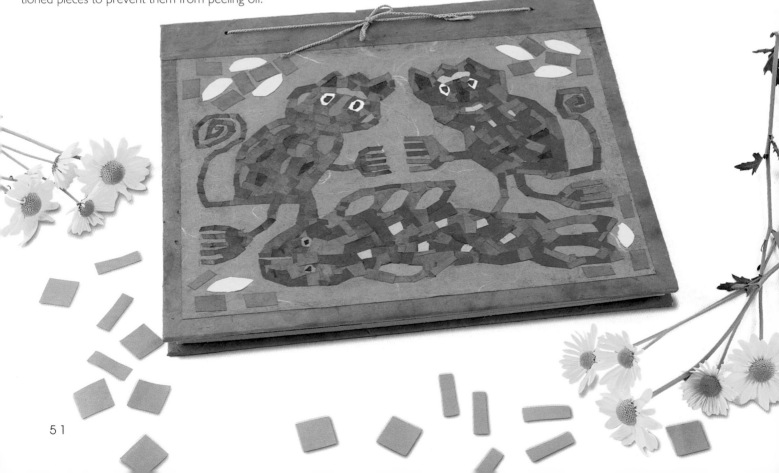

TIC-TAC-TOE GREETING CARD

DESIGNER: SUE L'HOMMEDIEU

Contrasting textures and ultrasimple design give this greeting card its distinctive, modest elegance. With half an hour's creative time and supplies you may well have around the house, voila!— you have a stunning card that lends a personal note to salutations for almost any occasion.

What You Need

1 sheet natural-colored card stock, 8½ x 11 inches (21.3 x 27.5 cm)

1 sheet black, finely corrugated card stock, 8½ x 11 inches (21.3 x 27.5 cm)

1 sheet natural-colored, lightweight, decorative paper, 7 x 10 inches (17.5 x 25 cm)

1 scrap ¹⁄₁₆-inch-thick (15 mm) corrugated cardboard at least 2 x 3 inches (5 x 7.5 cm)

Scissors

Craft Glue

What You Do

1

Cut the natural-colored card stock to 5½ x 8½ inches (13.8 x 21.3 cm), and fold it in half; this will be the card base. Cut the corrugated black card stock to 3⅝ x 4⅞ inches (10.4 x 12.2 cm), center it on the card's front, and glue it in place.

2

Cut the piece of decorative paper in half to 3½ x 5 inches (8.8 x 12.5 cm), and gently tear along one 3½ inch (8.8 cm) side to give the soft "torn" look shown in the photograph. Center it on the black card stock, and glue it in place. Cut a piece of black card stock 2 x 2½ inches (5 x 6.25 cm), center it on the handmade paper, and glue it in place.

3

From the scrap of corrugated cardboard, cut twelve ½-inch (1.3 cm) squares. Leaving an approximately ¼ inch (6 mm) border of black card stock on all sides, and about ¹⁄₁₆ inch (15 mm) spaces between all cardboard squares, place the squares in horizontal rows of three on the black stock. Arrange them so that the corrugated "grain" of the squares alternates, as the photograph shows. Glue them in place, and let the card dry for an hour or so before using.

LUXURIOUS
JOURNAL

DESIGNER: NICK CAVE

▲▲▲▲▲▲▲▲▲▲▲▲▲▲▲▲▲▲▲▲▲▲▲▲▲▲▲

The feel of velvet is a singular tactile pleasure, and getting your hands around this sumptuously covered journal at the end of the day is sure to multiply the delights of time you set aside just for you. Or make it as a gift for a friend who's just waiting for a perfect excuse to take time out from a hectic schedule.

What You Need

A blank book with black cloth cover, 8½ x 11 inches
(21.3 x 27.5 cm)

½ yard (1 m) handprinted or varicolored red velvet*

Scissors

White craft glue

NOTE: *For this project, the designer handprinted his own velvet, adding more and subtler color variations to the fabric. A good textile book can give you information on the handprinting process—or use store-bought fabric whose textures and colors give an appearance of some depth.*

What You Do

1

Cut the velvet into 80 or so squares of slightly varying sizes approximately 3 to 3½ square inches (7.5 to 8.8 square cm).

2

Leaving at least an ⅛ inch (3 mm) space between each square and the one beside it and/or the cover's edge, arrange the velvet squares in even rows on the front and back covers and in a column on the book's spine.

3

Glue them in place and let them dry for a couple of hours.

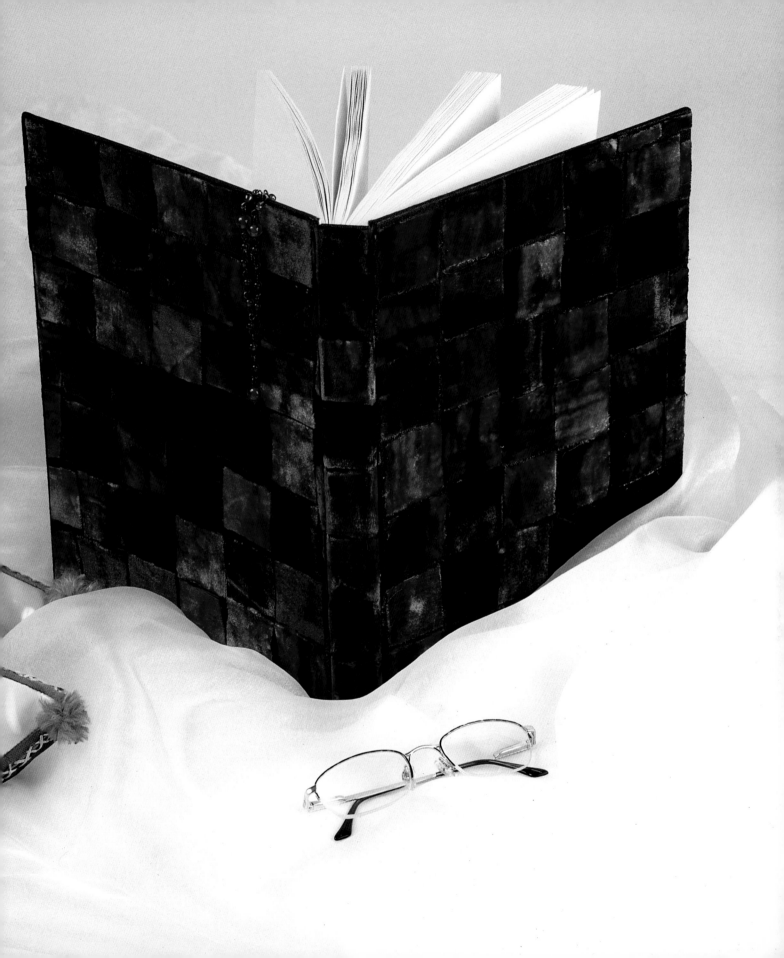

BIRDS-OF-A-FEATHER LEATHER CHAIR BACK

DESIGNER: DANA IRWIN

Combining wood, leather, and this M.C. Escher-inspired design creates a chair with a warm, rustic look and a hint of Moroccan flavor. If you don't happen to have a wooden chair that's crying out for a makeover, explore local thrift stores and flea markets for good specimens. With some simple adjustments, this project will also transform a bench back or glass-covered tabletop into pieces of furniture that will give their settings an artistic and distinctive note.

What You Need

Wooden chair with chair back of 16½ x 13½ inches (41 x 34 cm)

Piece of leather, approximately 10 x 11 x ¹⁄₁₆ inches (25 cm x 27.5 cm x 16 mm) for cut pieces

Piece of leather, approximately 9⅞ x 11 x ³⁄₃₂ inches (24.7 cm x 27.5cm x 23 mm) for backing, or adjust dimensions to fit the back of your chair

Pencil

Carbon paper

Sharp scissors

Textile dye, in desired colors

Paintbrush

Permanent black ink pen and/or black textile dye

Cyanoacrylate glue (any strong bonding glue that requires application to both surfaces)

Craft knife

Neutral shoe polish

What You Do

1

Using the pencil and carbon paper, transfer the drawing of the bird shapes on page 58 onto the thin leather piece. (You'll need to enlarge them to 140 percent)

2

Use freshly sharpened scissors to cut out the bird shapes.

(Leather can be difficult to cut.) Arrange the shapes in the pattern of the original drawing, or however you would like them to appear in finished form.

3

Mix the textile dye according to the manufacturer's instructions, then use the paintbrush to experiment with the dye on scrap pieces of leather until you achieve the color and shade you want. If you are working with pre-dyed leather (which is any leather that's not white), keep in mind that the color you're starting with will affect the color of the over-dye. To create subtle differences in color, try diluting the dye with water. This designer used an olive green dye on pre-dyed leather to attain a darker shade of the original color.

4

Once you've found a color that you like, use the paintbrush to apply dye to the alternating bird shapes in your design. You can either apply two different colors of dye to the alternating birds, or simply apply dye to one set of birds to achieve a shade that contrasts with the original color of their counterparts. Let the dye dry completely.

5

Using the permanent black ink pen, draw on details such as bird faces, feather lines, and other body contours. Outline each bird shape in black ink. If you're familiar with brushwork, you may find it faster to create detail with the paintbrush and black dye. Let the ink and/or dye dry completely.

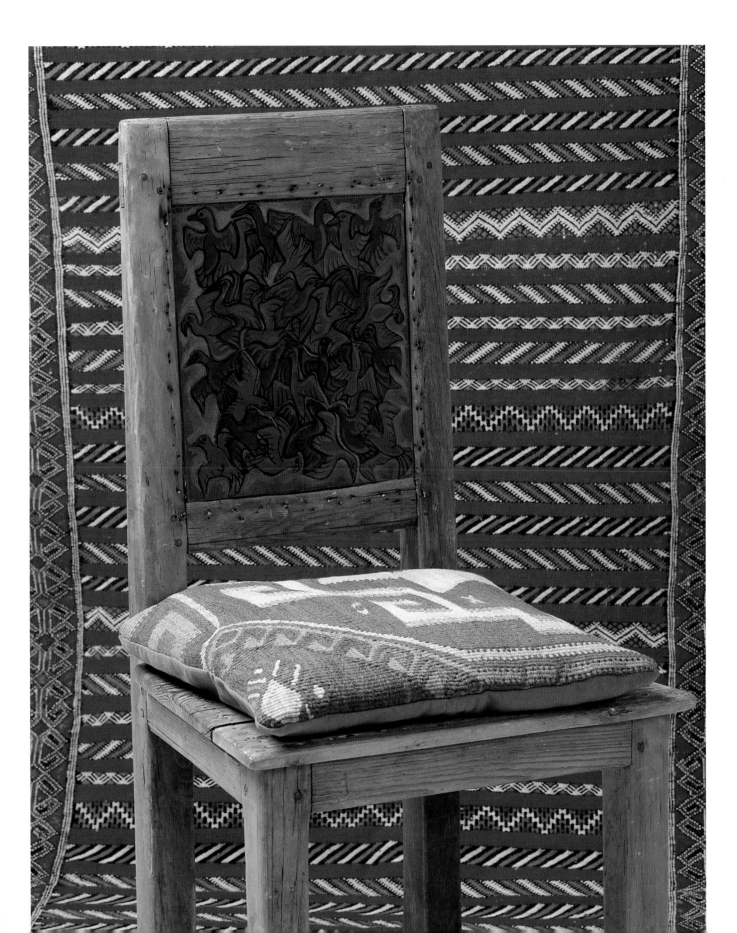

6

Glue the bird shapes to the thick leather piece. Arranging the pieces with variety, leaving more space between some and less or no space between others, may lend more of a mosaic look to the design. Let the glue dry completely.

7

To help the bird pattern stand out from the leather background, scratch around the bird shapes with the craft knife blade. The result should be a lighter shade of base leather, which will create a highlighted border around the birds.

8

Glue the base leather piece to the wooden chair back. Let the glue dry completely.

9

Apply a coat or two of neutral shoe polish over the installed

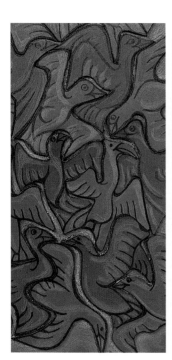

Stagger the positioning of the bird mosaic pieces to show more of the background leather and emphasize the relief of the individual bird motifs.

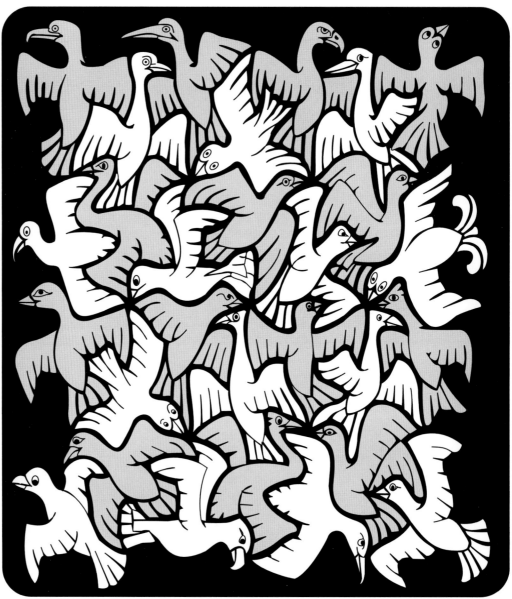

The Ultimate Functional Mosaic:

Fabric With A Motorized Twist

*M*osaics made with fabric can be elegant, cute, classic, whimsical—or flooring-it, fabulously funked-out and fun, like this road-ready fake-fur mosaic by artist Stephen Hooper (a.k.a. "Hoop"), which puts the alternative right back in automotive. One of many driveable works of art created by Hooper (and apt to turn a head or 10 even in NYC's less conventional neighborhoods), the mosaic covering this old Packard hearse includes "tesserae" of fake fur and leatherette, with the car's own surface doing duty as "grout," and a traffic-stopping border of neon streaks.

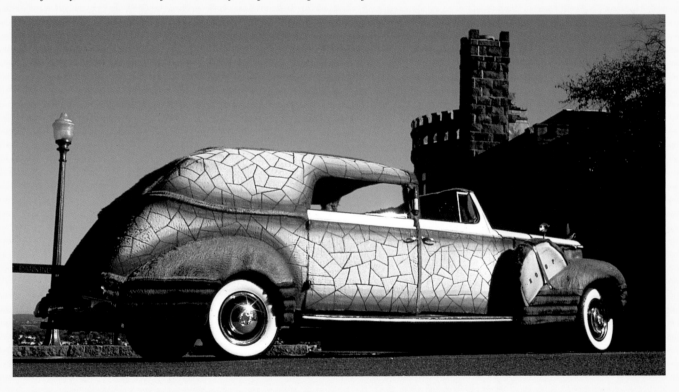

NATURALS

What could be easier

than gathering materials from your own

house and garden? As you'll see on the

pages to come, nothing-fancy materials like

a handful of flowers or rice, a couple of

cartons of eggs, or a plain old bushel of

beans, can be transformed into great-look-

ing practical pieces to perk up every room

in the house. Great fringe benefits, too: In

many cases, what you don't use to make

the mosaic you can conjure into your best-

loved culinary treats.

CLASSICAL SUN TABLETOP

DESIGNER: JEAN TOMASO MOORE

Here's betting the classical elegance of this tabletop mosaic becomes even more stunning when you discover its "tiles" are ... eggshells, broken and painted. Its bronze and metallic hues give a burnished look that hints at antiquity, yet its overall look is fresh and contemporary.

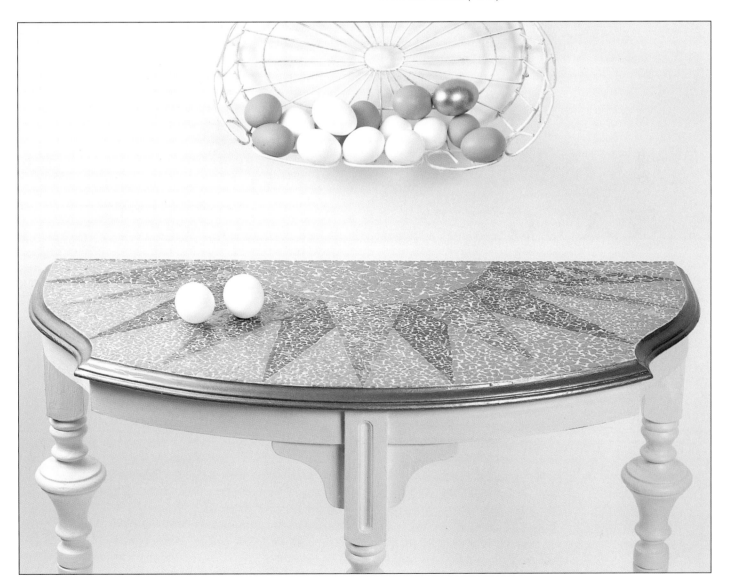

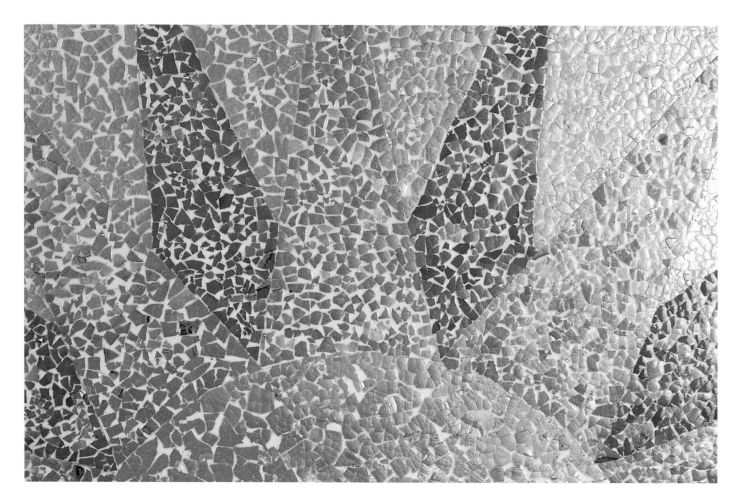

What You Need

· ·

A wood table—this one's 14 x 30 x 30 inches (35 x 75 x 75 cm), with measurements for the tabletop's width and length taken between longest points

1 qt. (950 mL) white semigloss latex paint

2 small bottles acrylic paint in different metallic colors (optional)

A few dozen eggs

Spray paint in 3 metallic colors

1 pt. (470 mL) high-gloss polyurethane

Tracing paper

Carbon paper

Craft glue

Paintbrushes (extra small, medium)

Pencil with eraser

Ruler

Compass

Tweezers

Foam brush (small)

Rag or sponge

What You Do

1

Choose a table with a smooth top whose shape will best accommodate your mosaic's design. A semicircular table devised to stand flush against a wall works especially well for the half-sun design used in this project. For a modified version of this design (for example, using a full sun design, and/or adding a border around the tabletop's edges), a round or even square tabletop can also work. The tabletop's dimensions can vary, depending on how large or small a sun design you wish to create.

2

Apply two to three coats of white paint to the whole table. On the tabletop, this will serve as the background color, or "faux" grout, of the mosaic. Allow each coat to dry overnight before continuing to work. (If your table has trim or decorative embellishments such as this one's curved double border around the tabletop's perimeter, you may want to use an extra-small paintbrush to paint these in contrasting metallic colors.)

3

Next, you'll need to make a design template. Place a piece of tracing paper on the tabletop. With a ruler and pencil, measure and mark the tabletop's center on the paper. Use a compass and pencil to draw the sun's center onto the paper; once the sun's center is located, use a ruler and pencil to add the sun's rays to the design. Remove the tracing paper and set it aside.

4

Using the template you've made on paper as a guide, estimate how many eggs you'll need to fill the design with eggshells. Hard-boil the eggs, let them cool (or run them under cold water to speed the process), then carefully peel off the shells. Remove as much membrane as possible from the shells' interiors.

5

Sort the cleaned eggshells into groups. If you're following exactly the the half-sun design shown, you'll need three groups—two same-sized groups to fill alternating rays of the sun motif, and a third, larger group of eggshells to fill the sun's center and spaces between the rays. Don't break the eggshells into tiny pieces yet; the larger the pieces are, the easier it will be to spray-paint them. Spray-paint each group of eggshells in a different metallic color. Allow these to dry.

6

Next, transfer the design onto the actual tabletop. Place a piece of carbon paper on the tabletop, then center and place the template you've made so that it's square with the tabletop's shape. Secure both with tape, then trace the design with a pencil. (It's best to draw the design lightly in pencil first.) Once you're satisfied with the transferred design's shape and symmetry, go over your lines again with slightly heavier pencil marks. Remove the carbon and template papers—your tabletop should now be clearly marked with the design.

7

Break the painted and dried eggshells into tiny pieces approximately the size of a baby's fingernail and slightly larger.

8

Working in small sections, evenly spread a thin layer of glue within the design's lines and use tweezers to place eggshells onto the glued surface. Arrange the pieces in a puzzle-piece fashion with a space of $1/16$ to $1/4$ inch (1.5 to 6 mm) between each piece, so that their edges match up with or echo those beside them. Align straight-edged pieces of shell with the design's straight lines, and use more triangular pieces to create the rays' points and angles. Once the shells in a small area are in place, gently smash them against the surface by pushing down with your fingers. (The eggshells will crack, giving a more "antique" look.) While you're working, use a damp cloth to clean excess glue from your fingers and the tweezers. Continue this process until the design's spaces are completely filled in. Let the finished design dry overnight.

9

With a foam brush, apply five to six coats of polyurethane to protect the finished surface against chipping. Allow each coat to dry completely before applying the next; allow the finished table to dry overnight before using.

SO MANY BEANS, SO LITTLE TIME CLOCK

DESIGNER: HEATHER SMITH

▲▲

Beans come in loads of colors, shapes and sizes, but their visual appeal pretty much disappears once they've been mashed, wrapped in a burrito's layers, or simmered into mere lumps of substance in a stew. But dried beans are inexpensive, readily available, and can be arranged to create patterns whose attractiveness belie their oh-so-humble origins.

What You Need

A precut ¾-inch-thick (1.9 cm) wood base 12 inches (30 cm) in diameter

1 set of prepackaged clockworks for ¾ inch (1.9 cm) clock base

Assorted dried beans (split green peas, kidney beans, white lima beans, black beans, pinto beans)

Acrylic paint (dark blue)

Wood glue

Matte acrylic varnish

Pencil

Electric hand drill with ¼ inch to ½ inch (6 mm to 1.3 mm) bits

Paintbrushes (small)

What You Do

1

Measure the wood base and mark its center with a pencil.

2

Drill a hole through the center point large enough to accommodate the clock shaft. Temporarily assemble the clock components on both sides of the base (accompanying manufacturer's instructions will provide information), and scatter a handful of beans under the clock hands to check for clearance. The clock hands must have a clear path for motion, and should not scrape over any beans as they move around the clock's face. If the hands easily clear the clock face, disassemble the clock parts.

3

Paint the wood base dark blue, and let the paint dry completely before proceeding.

4

Divide the clock face into quarters and lightly mark in pencil an X at noon, 3 o'clock, 6 o'clock, and 9 o'clock. Freehand draw or use stencils approximately 1 inch (2.5 cm) high to draw these numbers in the correct locations. Apply wood glue to the numerals' lines, place split peas right-side-up in the glue, and gently press the peas into the glue. (You can also use plastic or metal numbers glued in place, if you prefer.)

5

Using the Xs as starting points, measure and mark points approximately two inches apart around the clock. These points do not indicate other hour points; covered with beans, they will form the centers of the flowers that divide the remaining hour points. Glue a (slightly discolored, or yellowish) split pea upside-down on each of these 12 points; next, around each of the glued peas, arrange five white lima beans to form a flower.

When placing the lima beans closest to the clock's center, make sure to leave room to fit a split pea between them, as shown in the photograph. From this small triangular space, measure and mark a straight line to the clock's center, and position and glue upside-down split peas along these lines.

6

Next, arrange and glue kidney beans at contrasting diagonal angles, alternated with right-side-up split peas, to form the border around the clock's face.

7

Starting at the clock's center, fill in spaces between the split-pea "stems" with pinto beans to form a 2-inch-diameter (5 cm) circle. Select the thinnest and flattest beans for placement around the center of the clock under the clock hands.

8

Working in small sections, fill in the remaining spaces by positioning and gluing black beans close together. Let the glue set, then check for loose beans by lightly rubbing your fingers around the face. Reglue any loose beans.

9

To preserve and protect the beans, apply a light coat of varnish with a brush. Be sure to get in between the beans as much as possible. As the varnish dries, use a clean brush to smooth out any thick spots or bubbles. Allow the varnish to dry completely between each application.

10

Assemble the clock parts, set the hands, and hang the clock in a well-traveled room.

DRAGONFLY HOT PLATE

DESIGNER: LAURA ROBERSON

Simple geometric design and rich coloring lend this attractive and functional cork piece its uncommon appeal. It makes a great buffer between hot serving-dish bottoms and your good table linens—though it's so pretty, you may want to hang it on a wall or prop it on a mantel or shelf for all to see.

What You Need

Wine-bottle corks (20 or so)

A sheet of 1/16-inch-thick (1.5 mm) wood or cork, 8 x 8 inches (20 x 20 cm)

2 pieces scrap wood at least 8 x 8 inches (20 x 20 cm)

Fabric dyes (white, and a few shades of each of the following colors: red, pink, green, blue, and brown)*

Scrap of white cotton fabric at least 9 x 9 inches (22.5 x 22.5 cm)

Ruler

Pencil

Small handsaw

Craft knife

Craft glue

Small c-clamp

Foam brush

Rubber gloves

Steam iron

NOTE: *Fabric dyes stain quickly and thoroughly. Be sure to wear rubber gloves and an old smock when using them.*

What You Do

1

Gather 20 or so saved or purchased wine corks. Lay a cork lengthwise on its side on a cutting board or like surface; starting at one end, use a ruler and pencil to measure and mark the cork across its diameter at 1/4 inch (6 mm) intervals. With a small handsaw, cut straight across and down through the cork at the points you've measured and marked. You'll now have several 1/4-inch-thick (6 mm) round segments of cork like small coins. With a ruler and craft knife, cut each cork "coin" into approximately pieces approximately 1/16 inch (1.5 mm) square and slightly larger (approximately 600 pieces total).

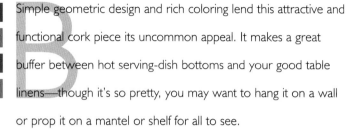

2

Working in rows, glue cork squares onto the wood or cork backing until the surface is covered. The edges of all cork squares should be flush with those of the pieces beside them; pieces around the backing's perimeter should be flush with, but not overlapping it. You may need to cut a few larger or smaller pieces to fill in spaces. When all of the pieces are glued, clamp the cork-covered backing fairly tightly between two pieces of wood, and leave it to set overnight. Then remove the hot plate from the clamps and return it to your work surface.

3

With fabric dyes and a foam brush, paint the single row that forms a border around the hot plate's perimeter in different shades of green. Measure down seven rows from the top border, and seven rows in from the left-hand border, and paint this square blue—this is the tip of the dragonfly's head. Using this square as a starting point, follow the photograph and sketch the outline of the dragonfly's body and wings onto the cork. Painting

a square at a time, use different shades of green and blue to color the dragonfly's body, and shades of red and pink to color its wings. Here and there, as shown in the photograph, paint groups of squares green and brown to give an abstract landscape look. Set the hot plate aside to dry overnight.

4

Place a piece of white cotton fabric over the hot plate, and run a steam iron back and forth over the covered hot plate. The steam will set the dyes. Allow the finished piece to sit overnight before using.

EARTH-CAST BIRDBATH

DESIGNERS: SANDI AND BRIAN PRICE

This charming rustic birdbath makes a great watering hole for all your winged visitors and is as much fun to make as it will be to watch your favorite feathered friends frolic in it. Gardeners will especially love this earth-casting technique, which lets you get your hands in the dirt to create a functional ornament for the garden.

What You Need

Plastic tray, 2 to 3 ft. (60 to 90 cm) deep

Vegetable shortening

30-lb. (13 kg) bag of acrylic concrete mix

1 to 2 gallons (3.8 to 7 L) of small gravel

Assorted seashells

An assortment of clear glass florist's marbles (flat on one side)

1½ lbs. (672 g) of white grout (unmixed)

Acrylic paint

Clear acrylic sealer

Concrete or stone decorative column or pedestal

Shovel

Cloth

5-gallon (19 L) (or larger) bucket

Wood stick to mix concrete

Brush

Paintbrushes (small, large)

Industrial-strength clear craft adhesive

Rubber gloves

Large plastic palette to mix grout

Plastic container for mixing grout

Sponge

What You Do

1

Collect and purchase a pretty assortment of seashells and florist marbles. Choose an area of your backyard or other usable location that can be excavated without disrupting flowers, grass, or other growth. With a shovel, dig a hole approximately 2½ inches (6 cm) wider than your plastic tray. The sides of the hole can be left rough for a rustic casting, but the bottom must be level and firmly packed, so the finished birdbath will sit flush on the pedestal. Keep the excavated dirt in a pile nearby.

2

Use a cloth and vegetable shortening to grease the exterior surfaces of the plastic tray. Set it aside for now.

3

Mix concrete in a bucket according to the manufacturer's instructions. You'll need to mix approximately ⅔ of the 30-lb. (13 kg) bag to create a birdbath this size. A handful or so at a time, add gravel to the mix as aggregate. This will help the concrete form a mortar.

4

Pouring slowly, fill the hole with concrete until it is ⅔ full. Immediately and carefully press the plastic tray into the wet concrete until the concrete rises up to meet the tray's top edges. Do not let the concrete spill over into the tray, or the tray will be difficult to remove once the casting is dry.

5

Mix remnants of the mixed concrete with the dirt you removed from the hole in step 1 and water to form a slurry paste. Rub the paste onto the base of your column or pedestal to give it a "distressed" look.

6

Allow the poured concrete to set and harden in the ground for

several hours. When it is sufficiently dry to remove the tray, carefully lift the tray out. Set the tray aside. Allow the in-ground concrete casting to harden, exposed to the sun and air, until it is completely dry.

7

Remove the casting from the ground by digging around it with a shovel. Do not pry it out, as the dry concrete has not yet achieved its maximum strength. Brush loose dirt from the concrete casting's surfaces.

8

Create a pleasing design of shells, marbles, and gravel in the plastic tray. With a disposable paintbrush, apply a dab of adhesive to each piece and position and attach it in the corresponding space in your casting. The adhesive will take 10 to 15 minutes to dry, so you'll have some time to adjust your design if necessary. Let the attached pieces set overnight.

9

Wearing rubber gloves, mix grout so that it forms a batterlike consistency. Add small amounts of acrylic paint to the grout mixture to tint it. Spread a thin, even layer of colored grout over the inside surface of the birdbath, pressing grout into crevices and around the edges of shells and other pieces with your fingers.

10

Allow the grout to sit for 15 to 20 minutes, until it begins to dry around the edges of the birdbath and attached pieces. Softly sponge off the tops of shells and marbles, rinsing the sponge often. (Note: Porous materials, such as those of sand dollars, will absorb color from the paint and will be brighter than the color of the dried grout.)

11

Let the finished mosaic dry for 48 hours, or until it is completely dry to the touch. Apply one or two coats of clear acrylic sealer to the inside surface of the birdbath, allowing the sealer to dry thoroughly before placing the birdbath on the pedestal or column you've chosen.

MONET VASE

DESIGNER: PERRI CRUTCHER

▲▲▲▲▲▲▲▲▲▲▲▲▲▲▲▲▲▲▲▲▲▲

A delicate palette of dried flowers creates the Impressionist feel of this vase's floral design. Filled with flowers that complement its shape and hues, it makes a stylish yet practical piece sure to delight garden lovers and artistic eyes alike.

What You Need

3 long-stemmed roses with leaves (2 dark red, 1 yellow)

1 small bunch rice flower (white)

1 stalk boxwood (dark green)

1 stem sea foam statice (purple)

1 sprig lavender (purple)

1 strawflower (with orange blossom)

Ceramic vase—this one's 5¾ x 9 x 9 inches (14.4 x 22.5 x 22.5 cm), with measurements for width and length taken from the vase's longest points

Craft glue

Clear spray varnish

Pencil (optional)

What You Do

1

Gather all flowers and set them aside to dry for two to three weeks.

2

When all blooms are dry, gather them on a work surface. As you separate parts of different flowers and plants from their stalks and stems, keep blooms sorted into separate piles. With your fingers, gently crumble the rice flower, statice, and lavender so that individual, tiny blooms are separated from one another. Carefully remove the leaves and petals, keeping them as intact as possible, from all of the roses. Gently strip the boxwood's leaves from its stalk. Last, carefully remove the strands of the strawflower's blossom. Discard stems, leaves, and other parts of flowers and plants not removed.

3

Since this designer used an unusually shaped vase and created a design to echo its contours, you'll need to adapt the design shown to your vase's shape. (You may want to freehand sketch or stencil a floral design onto the vase in light pencil first.) Working in a small area at a time, spread a thin layer of glue onto the vase; position petals or leaves flush with one another or overlapping slightly, and gently press them into the glue to secure them. This design uses white rice flower for the bottom border and background on the vase's upper portion; red rose leaves to fill in the vase's lower portion; boxwood leaves for the flowers' "stems"; statice, lavender, and yellow rose petals to create the flowers' heads; boxwood and rose leaves (light green) for filler greenery and accents; and strands of strawflower blossom for the yellow flower's center.

4

When the flower mosaic is complete, spray the decorated area with a coat of clear varnish. Let it dry completely before using.

MOON-AND-STARS BOX

DESIGNER: JEAN TOMASO MOORE

▲▲▲▲▲▲▲▲▲▲▲▲▲▲▲▲▲▲▲▲▲▲▲▲▲▲

Reinventing the old elementary-school macaroni-mosaic trick with panache, this project proves that even the least expected materials, used creatively, can produce great results. It's not for the less patient among us, but makes a fantastic little container for trinkets—or tilt the lid and fill it with your favorite potpourri.

What You Need

Round cardboard box with top, 5½ inches (13.8 cm) in diameter

Paper

A handful of white rice; a few pinches each of brown and wild rice

Carbon paper

Craft glue

Acrylic clear gloss

Pencil

Scissors

Paintbrush (extra small, small)

Tweezers

Sponge

What You Do

1

Place the box top on a piece of paper and trace its circumference. Set the top aside, and cut out the drawn circle. Following the photograph or adapting the design shown to your own preferences, draw a moon-and-stars design within the circle. Use carbon paper and pencil to transfer the design on to the box top.

2

With your finger or the handle-end of a tiny paintbrush, spread glue along a small area of the design's outlines—the striped, crescent-shaped border on the right, half-moon face, and stars. Position pieces of wild and brown rice along the glued area and press them in place with tweezers. Continue, working a small area at a time so that the glue doesn't dry before you can place the rice, until the entire outline is covered. Clean excess glue from your fingers and tweezers with a damp sponge as you go.

3

Using the method described in step 2, glue in place pieces or tiny clusters of wild rice to create the crescent border's striped pattern, the stars, and the moon's eye, nostril, mouth, and other accents. Use brown and white rice to fill in the design until the surface is covered.

4

Apply a thin, even coat of acrylic clear gloss to the rice mosaic. Allow the finished box top to dry completely before using it.

Mosaica Americana:

THE MITCHELL CORN PALACE

Outrageous architecture aside, the mosaics themselves are veritable Wonders Of The World. Nearly all the exterior area of the building is covered with mosaics depicting scenes from or motifs of South Dakota life—more stupefying yet, each year a new theme is devised, the existing mosaics are removed, and new ones are created. Thousands of bushels of corn in nine different natural colors, along with massive quantities of grains, grasses, wild oats, brome grass, blue grass, rye, straw, and wheat are cut, tied, and nailed in place to artists' specifications. More amazing yet, there are several more mosaic murals inside—good testament that, with an original idea, the most commonplace and humble material can go a long and fun artistic way.

*M*osaics made from the earth's own bounties don't get bigger or better (at least at the same time) than those covering the walls of Mitchell, South Dakota's, famous Corn Palace. A must-see for agrarians, road-trippers, and lovers of outsider art and everything kitsch, this truly-and-only American phenomenon started in 1892, when a first building was built and decorated to display the yields of South Dakota's fertile soil, and lure settlers to the Great Plains. Not surprisingly, visitors flocked from far and wide to check out the mosaicked structure. Another, larger building was built to cope with curious crowds—and, in 1921, it was replaced by the present Corn Palace, complete with fantastic Moorish turrets, domes, and minarets.

CHAPTER FIVE:

GLASS, METALS, MARBLE, STONE, & CLAY

Sand, ore, rock, and earth. They make up the ground beneath us, and their constancy and substance nurture and reassure us. Likewise, the materials they give us invite and allure ... the mystery and translucence of glass ... the gleam and glow of gold and silver and copper ... the sudden life that surfaces in a chunk of polished granite ... the primal flow of clay through your fingers ...

It's great to take time out and work with materials such as these, which many of us don't lift and feel in our hands every day. This chapter offers the opportunity to do just that, and to make all kinds of unique objects for home and garden that will give you pleasure for years to come.

CAP-TIVATING HEART
WALL HANGING

DESIGNER: SHERRI WARNER HUNTER

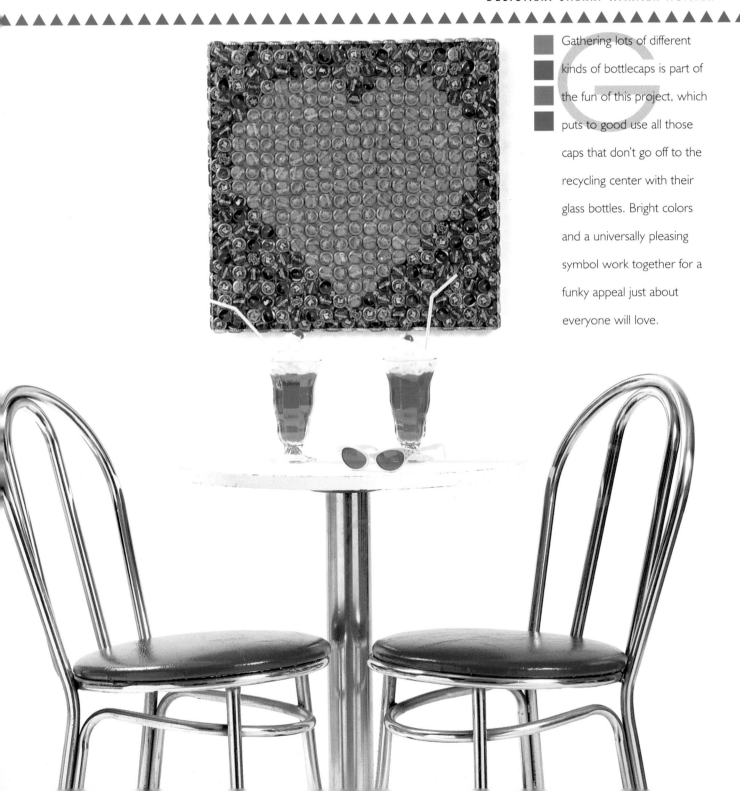

Gathering lots of different kinds of bottlecaps is part of the fun of this project, which puts to good use all those caps that don't go off to the recycling center with their glass bottles. Bright colors and a universally pleasing symbol work together for a funky appeal just about everyone will love.

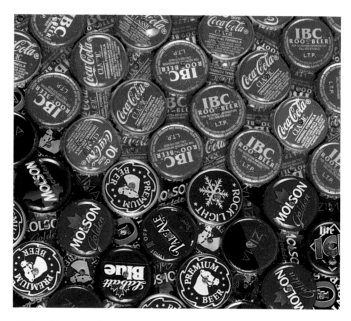

What You Need

361 red metal bottle caps

481 blue metal bottle caps

1 sheet ¾-inch (1.9 cm) thick plywood, 22 inches (55 cm) square

2 wood 1 x 2s, each 16 inches (40 cm) long

Wood glue

6 drywall screws, 1¼ inch (3.1 cm) long

2 pts. (470 mL each) semi-gloss latex paint (1 light-colored, 1 black)

2 eye screws (½-inch [1.3 cm]-diameter eye)

Heavy-duty picture-hanging wire, approximately 30 inches (75 cm)

⅝-inch (1.6 cm) 18-gauge nails (with heads)

1-inch (2.5 cm)18-gauge nails (with heads)

Heavy-duty picture hook

Medium-grit sand paper

Yardstick

Pencil

Paintbrush (medium)

Electric hand drill with ¹/₁₆ inch (1.5 mm) bit and screw driver bit or awl

Small hammer

Scrap of ¾-inch-thick wood (1.9 cm), 2 to 3 feet (60 to 90 cm) wide and 12 to 18 inches (30 to 45 cm) long

NOTE: *Any standard 1-inch (2.5 cm) diameter metal bottlecaps with fluted edges will work. Don't use bent or badly scratched bottlecaps.*

What You Do

1

Gather and clean all bottle caps of any residual traces of beverage by swishing them around in mild soapy water, rinsing them, and setting them out on towels to dry thoroughly.

2

Lightly sand all edges of the wood boards to minimize splintering. Assign a front (where you'll create the mosaic), back, top and bottom for the piece of plywood. *(Note: The wood's grain should run vertically, top to bottom.)* Use a yardstick to find the plywood's center and mark it with a vertical line from the top of the board to the bottom. Measure 4 inches (10 cm) down from the board's top on both sides, and draw a horizontal line across the board (and wood grain) at these points. Measure up 4 inches (10 cm) from the bottom, and mark again in this manner.

3

Place a 1 x 2 face up on a work surface, and measure and mark its center. Measure in 2 inches (5 cm) from the short ends of the board's face, and mark. With a drill, bore pilot holes at these three points. *(Note: A pilot hole is a "starter" hole drilled before installing the screw; it will minimize splintering and chipping of wood when a screw is installed.)* Repeat this process with the other 1 x 2. Position one 1 x 2 aligned with the center line and with its top edge flush with the line you've drawn across the board's upper portion. Apply wood glue to the back of the 1 x 2 (this will help fix it in place), reposition it, and install a screw through the center hole and flush with the 1 x 2's surface. Once the center is fixed, move the board to find its level position, and install screws through the remaining holes. Paint the entire side you have just worked on with a light color (dark paint may scuff walls), and let it dry completely. To install hanging wire, measure in 4 inches (10 cm) from each end on the top edge of the upper 1 x 2. Center and mark these points; drill a pilot hole at each point. Install eye screws in both holes and tighten them. Attach picture-hanging wire lengthwise between the eye screws, loop-

ing in tightly between and around the screws and trimming any excess. Turn the whole construction over, front side up, and paint the front surface and edges black. Allow to dry competely.

4

Now you're ready to make the bottlecap mosaic. Start by using a pencil and yardstick to measure and mark lines dividing the front surface into exact quarters.

5

The design plan for both layers of this mosaic is shown below. Using it and the photograph as guides, you'll start by attaching a first layer of blue bottlecaps to the plywood surface with $\frac{5}{8}$-inch (1.6 cm) nails. First, select one blue bottlecap and place it on a firm work surface. Hold a nail at end down at the cap's center, and use a hammer to tap it sharply through the cap. Now position the nailed cap, with its fluted edge on slightly over the

board's edges, at the board's top right-hand corner. Hold the cap tightly against the board with one hand, using the other hand to hammer it into the board. (Don't hammer too hard, as you'll dent or smash the cap.) Use this method to place and nail a row of 20 caps across the top of the board. Repeat this process working toward the bottom, stacking each row directly below the previous one, until the surface is covered. You'll use a total of 400 blue and red caps for this layer.

6

On the bottom layer, every juncture where four caps meet will form a small, diamond-shaped space; form the second layer by using 1-inch (2.5 cm) nails to attach caps centered over these spaces. Continue until the design is complete. To attach caps to the sides, use 1-inch (2.5 cm) nails and position caps flush with one another.

LUMINOUS GLASS CANDLE HOLDER

DESIGNER: TONI FURBRINGER-LONG

Whether you gather pieces of beach glass from the seashore or the craft store, their marvelous shapes, textures, and colors lend themselves well to all kinds of gorgeous combinations. Lit from within, this glass mosaic throws off beautiful blue, rose, and golden tones as quiet and peaceful as an oceanside sunrise.

What You Need

Glass vase or candle holder (with smooth exterior surface), 5¾ inch (14.5 cm) diameter and 8½ inches (21.3 cm) high

"Beach" glass in a variety of shapes and sizes (light, medium, and dark blue; light and medium-dark pink, and light yellow; approximately 600 pieces total)

Strong clear silicone adhesive

Paintbrush (small)

What You Do

1

Since even pieces of purchased beach glass are irregularly shaped and sized, the patterns you create on your candle holder will necessarily differ from the one pictured. Let the photograph or your own creative instincts guide you in composing a pleasing abstract design.

2

Sort the gathered beach glass by color into piles. With a small brush, spread a thin layer of adhesive over a small section of the candle holder's surface. Grouping a few pieces of glass in shades of a single color together, place and press pieces onto the candle holder's glued surface, close together in a puzzle-piece fashion. (Very narrow spaces of ⅛ to ¼ inch (3 to 6 mm) between pieces will not detract from the overall look of the finished candle holder.) Continue arranging and affixing groups of like-hued pieces next to groups of a different color, until the candle holder's surface is covered.

3

Allow the finished piece to dry for 48 hours before lighting a candle inside it.

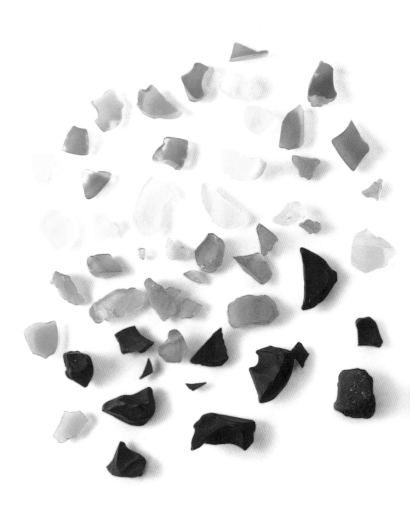

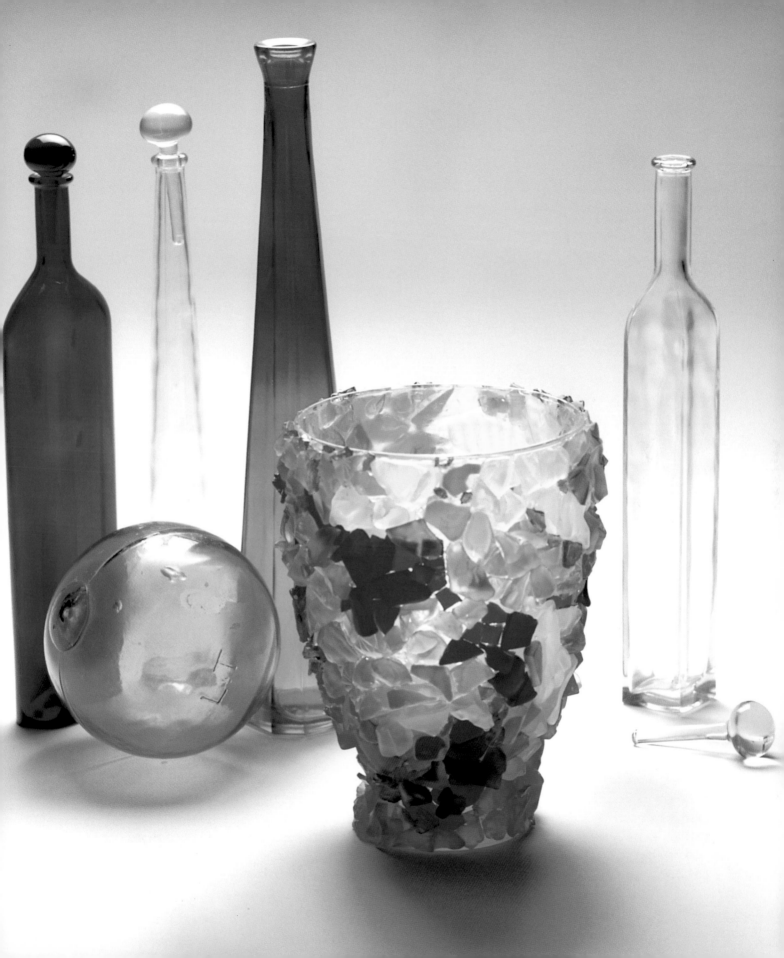

ATLANTIS MIRROR

DESIGNER: CATHERINE DELGADO

▲▲▲▲▲▲▲▲▲▲▲▲▲▲▲▲▲▲▲▲▲▲▲

Cool aquatic hues flow around this mirror's circumference to give it an inviting look worthy of the most glorious underwater kingdom—or more humble earthly abode. Its simplicity and soothing tones lend a gentle elegance to any room.

What You Need

A ¾-inch-thick (1.9 cm) round wood frame with 2 inch (5 cm) surface width, 12 inches (30 cm) in diameter

1 round mirror, 12 inch (30 cm) diameter

57 ¾-inch-diameter (1.44 m) iridescent green glass buttons

1 sheet varicolored irridescent stained glass (including pale green, blue, ivory, and rust or "terra-cotta" tones), 12 x 12 inches (30 x 30 cm)

Ceramic tile adhesive

1 cup (224 g) sanded grout (unmixed)

Safety glasses

Glass nippers

Plastic containers for mixing grout

Plastic knife or palette knife for mixing grout

Small float

Latex gloves

Sponge

Soft cloth

What You Do

1

Place and glue glass buttons around the outside of the frame, flush with the bottom edge and each other. (A tiny space between a piece or two is okay.)

2

With glass nippers, cut the stained glass into small roughly geometric shapes with no sides longer than 1 inch (2.5 cm). Play with different arrangements of these pieces on the frame's top 2 inch (5 cm) surface, leaving at least a ⅛ inch (3 mm) space between all pieces. Pay attention to the "flow" of different colors between adjacent pieces. When you've found the composition that most satisfies you, glue the pieces to the surface. Let dry for 30 minutes.

3

Cut 32 small pieces of glass approximately ½ inch (1.3 cm) square. Carefully place and glue them around the inside of the frame, flush with the bottom edge and with ¹⁄₁₆ to ⅛ inch (1.5 mm to 3 mm) spaces between them. Let this surface dry for 30 minutes.

4

Grout the mosaic in small sections. With a float, spread and smooth mixed grout over a small surface area so that all uncovered spaces between glass pieces are filled. Wear gloves, and use your hand to apply grout along the outside's glass-button mosaic; spread enough grout between buttons so that they appear to be spaced ¼ inch (6 mm) or so apart. Let each grouted area sit for 10 minutes, then use a sponge or damp cloth to remove excess grout; after another five minutes or so, remove any remaining excess traces of grout.

8

Let the fully grouted frame sit for an hour, then buff the surfaces with a cloth. Let the finished mosaic dry for 48 hours.

9

Center and place the mosaic frame over the mirror. When you've found its correct position, apply an even layer of adhesive to the back of the wood frame and the surface of the mirror where it meets the frame, and attach the two. Allow the glue to dry for 48 hours.

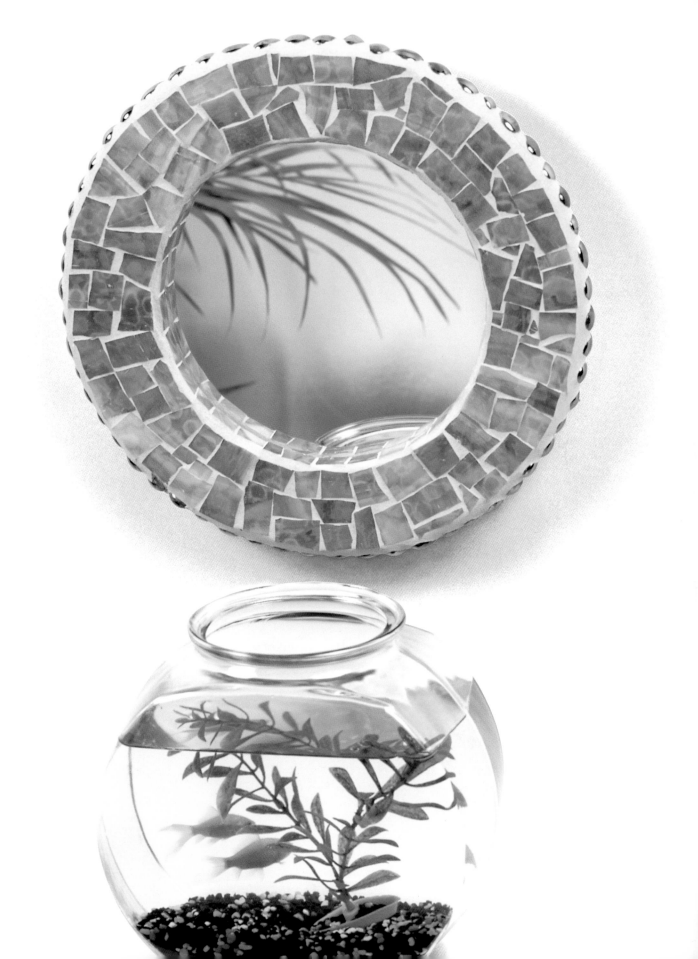

FAUX JADE JEWELRY

DESIGNER: CAROLYN POTTER

▲▲▲▲▲▲▲▲▲▲▲▲▲▲▲▲▲▲▲▲▲▲▲▲▲▲

Delicate pastel shades of jade, violet, gold, and sienna contrast boldly to make this set of wearable accessories a strong fashion statement that's sure to invite compliments. Wear them for a stunning everyday look, or bring them out for those occasions when you want to stand out a little from the crowd.

What You Need

Polymer clay (two 2-oz [56 g] blocks translucent; one 2-oz [56 g] block violet; ¼ block dark turquoise; and ¼ block orange)

Small package of clay softener

One ½-inch-long (3.8 cm) silver backing for pin

2 ½-inch-diameter (6.3 cm) silver backings for earrings

One 2-oz (56 g) block brown polymer clay

Pasta machine (optional)

Smooth glass jar (optional)

2 pieces of ⅜-inch-thick (9-mm) modeling board, or 4 popsicle sticks

Ruler

Craft knife with standard-sized blade

Sewing needle or other sharp pointed tool (for sketching on clay)

Manila folder

Oven

400- and 600-grit wet/dry sandpaper

Small dish of water

000 steel wool

Clay or wood modeling tool with flat curved edge to press clay grout into seams

320-grit wet/dry sandpaper

Denim cloth or muslin buffing wheel

Cyanoacrylate glue

What You Do

1

Condition each block of clay separately by rolling it between the palms of your hands. (If you put it in your pocket first, your body heat will warm it up and make it easier to work with.) Once you can make a snake and fold it back on itself without the clay cracking, it is ready to work with. As it grows softer, roll it into a ball and pinch it into a flat piece.

2

To make the colors for the mosaic, add a pea-sized amount of color to portions of the translucent clay. Mix these into a solid color by rolling the clay into long snakes, twisting it up, and rolling it out again until you achieve the desired hue.

3

If you have a pasta machine, you can keep conditioning the clay with your machine until it looks and feels like soft leather. To do this, set your pasta machine to its highest setting (for thickest extrusions) and run the flattened clay through; then set the machine to its lowest setting (for thinnest extrusions), and run the clay through again. Repeat this process, or put the clay through 10 times at the thinnest setting (folding it back on itself and putting it back through each time) about 10 times until the clay looks and feels like soft leather. (Note: If the clay crumbles, you are putting the clay through too thick or the setting is too high; fold [do not roll] the clay into a thicker piece.) Once the clay is sufficiently soft, fold the clay over several times; set the pasta machine on its lowest setting, and pass it through one last time. The clay should be approximately ⅛ inch (3-mm) thick.

4

If you don't have a pasta machine, simply use a smooth glass jar to roll the clay to an even thickness. Don't use a rolling pin or any other kitchen utensil that you plan to use with food in the future. To get the even thickness you would achieve with a pasta machine, place two thin pieces of wood or two popsicle sticks on either side of the clay and roll the bottle on top of the wood.

5

Trace or photocopy the patterns on page 000, and place them on the clay. Using a ruler and craft knife, mark and cut out the

base shapes for your pin and earrings. Set these aside for now. Cut the remaining clay into 1/4-inch-high (6-mm) strips. Use the needle to sketch out your design on the clay base. Use the craft knife to cut tiles from the 1/4-inch-high (6-mm) strips to fit into the design. Most tiles will be approximately 1/8 inch (3 mm) thick. When the mosaic is complete, roll the craft knife's handle or a smooth glass jar over the surface.

6

Bake the finished pieces on a manila folder in the oven at 265° F (130° C) for 20 minutes. Because polymer clay hardens as it cools, the clay will still be flexible when you take it out of the oven. You can place a book on the pieces after they come out of the oven to keep them flat, if desired.

7

Working with one piece at a time, sand the backs and sides of the pin and earrings gently with fine 400- and/or 600-grit wet/dry sandpaper in a small dish of water (to prevent dust inhalation) to clean up the edges. Rub a small piece of 000 steel wool over the back and side surfaces.

8

Mix equal parts of the brown clay and clay softener. You'll use this mixture to "grout" the clay mosaic. Gently push the mixture between the clay tiles. Use the flat, curved modeling tool to scrape off as much excess of this mixture as possible. Harden the pieces again for 20 minutes at 265° F (130° C) in the oven.

9

Sand all sides of the pin and earrings with 320-grit wet/dry sandpaper. Then use the fine dry-wall sanding screen or a wet-dry sponge with fine/medium grit to sand again. Finally, sand again with 400- and 600-grit wet/dry sandpaper in a small dish of water to keep from inhaling the dust. Buff the pieces with a muslin wheel or a piece of denim cloth.

10

Center the backs and use cyanoacrylate glue to attach them to the pin and earrings. Allow the glue to dry thoroughly before wearing the jewelry.

STONE-AND-MARBLE MIRROR

DESIGNER: CATHERINE DELGADO

Gorgeous natural blacks and grays mingle on this mirror's border to create a classic look that's equally at home in a small Latin American village or ultraurban Big Apple brownstone ... and the pleasure of working with stone—feeling its weight and textures in your hands—is in a league of its own.

What You Need

A 1-inch-thick (2.5 cm) round wood frame with 3-inch-wide (7.5 cm) surface, 16 (40 cm) inches in diameter

1 mirror, 16 (40 cm) inches in diameter

1 black wrought-iron frame with decorative embellishments, 17 inches (42.5 cm) in diameter (22¾ inch (56.3 cm)-diameter including decorations)

30 to 40 roughly triangular ½-inch-thick (1.3 cm) pieces of tumbled white and gray granite or other stone, with no sides longer than 2 inches (5 cm)*

70 roughly geometric ¼-inch-thick (6 mm) pieces of veined black marble, with no sides longer than 1¾ inches (4.4 cm)*

33 pieces of white granite or other stone, ½ inch (1.3 cm) thick and 1 inch (2.5 cm) square*

1 cup (224 g) sanded grout (unmixed)

Ceramic tile or masonry adhesive

Masking tape

Float

Hammer (optional)

Safety glasses

Plastic container for mixing grout

Cloth or sponge

NOTE: If pieces of stone and marble you've gathered are too big or not triangular enough, use a hammer to break them on a sidewalk. Make sure to hold the hammer with the head slightly tilted, so the head's corners (not its flat surface) hit the stone. Also, if you're not using a wrought-iron frame for the mirror, you'll need more white granite or other stone to mosaic the wood frame's outside edge.

What You Do

1

Select all the white and gray stone triangles. On the wood frame, arrange them around the inside of the frame's face to form sun rays. The triangles should be positioned ⅛ to ¼ inch (3 to 6 mm) away from the face edge, with their bases aligned. Place one or two smallish triangles next to a bigger one, alternating sizes around the frame—you want the overall composition to have an even look. Experiment with different arrangements to find the best one. Apply a thin, even layer of adhesive to the frame's surface and glue the pieces in place.

2

Next, experiment with arrangements as you did in step 1 to fill in the remaining surface area of the frame's face with pieces of black marble. Keep positioned marble pieces ¼ inch (6 mm) away from the stone rays and each other; pieces positioned at the frame face's outside edge should ideally be flush with the edge and should not exceed it. Start by fitting inverted triangular pieces between rays, then work out toward the edge. Again, place different-sized pieces near each other, creating an overall even composition. When you've found the most satisfying arrangement, glue the pieces to the frame. Let the glue dry for two hours. (Note: If you opt not to use a wrought-iron-frame surround, use geometric pieces of stone and marble to create a mosaic design on the outside of the frame using the above-described method.)

3

Select all the white stone squares, and turn and hold the frame on end. Working in quarter sections of the frame's interior border at a time, rotate the frame to position and glue the squares ⅛ inch (3 mm) apart and flush with the top edge. Let a section's worth of glued squares set for 40 minutes before turning the frame to attach more squares; let the last glued section dry for 40 minutes before proceeding.

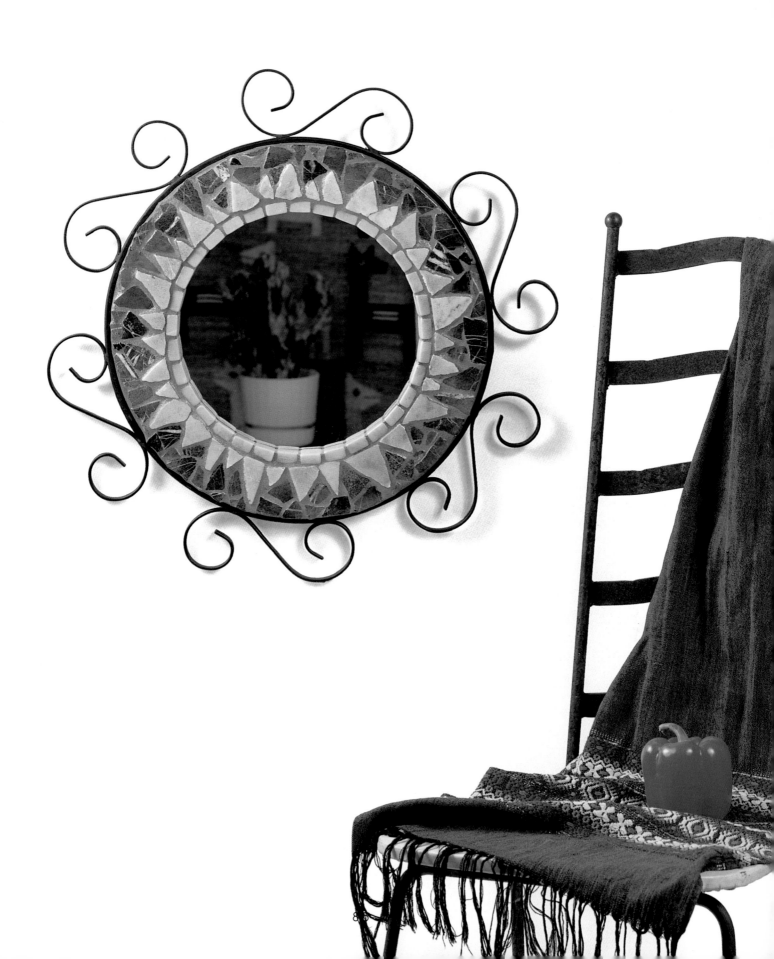

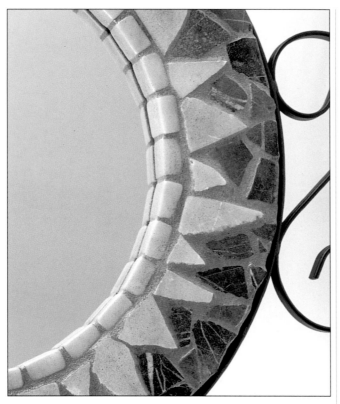

"COPPER GARDEN" PLANT STAND

DESIGNER: KATE BREWER FISHER

▲▲▲▲▲▲▲▲▲▲▲▲▲▲▲▲▲▲▲▲▲▲▲

Bright and subtle patinas of new and aged copper combine to give this sweet mosaic an antique feel—geometric shapes set against a pretty, curved floral motif add to its visual texture. Put a pot of your favorite flowering vine beneath and let leafy tendrils wind their way up, or use the top as a place to house a nice little lamp or ... nothing but its own good looks.

4

Before grouting, mask the mirror to protect it. Mix grout according to the manufacturer's instructions; it should be about the consistency of cake frosting or mashed potatoes. Wearing gloves, use your hands and a float or piece of packing foam to scoop and spread grout into the small spaces between shards of tile until the entire surface is well covered. Allow the grout to set for 15 or so minutes, then use a damp sponge or cloth to wipe the surface clean, removing all excess grout on or between tiles. Let the grouted mosaic set for 30 minutes, then use a damp cloth or sponge with water to remove any final traces of excess grout. Allow the finished mosaic to dry for 48 hours.

5

Center and place the mosaic frame over the mirror. When you've found its correct position, apply an even layer of adhesive to the back of the wood frame and the surface of the mirror where it meets the frame, and attach the two. Allow the glue to dry for 48 hours before installing it in the wrought-iron frame you've chosen.

What You Need

Old wooden plant stand painted white (this one's 25½ inches (63.8 cm) high, with an 8-inch-square (20 cm) top surface area

1 sheet oxidized copper, 9 x 9 inches (22.5 x 22.5 cm)

2 old painted tin roof shingles (1 faded red, 1 faded yellow), each 4 x 4 inches (10 x 10 cm)

1-inch-square (2.5 cm) scrap corrugated copper

Light-gauge copper wire, about 5 ft. (1.5 m)

8 copper tacks with ⅛-inch-diameter (3 mm) heads

Safety glasses

Leather gloves

Tin snips

Craft scissors

Ruler

Pencil

Strong clear silicone adhesive

Small pliers

Hammer

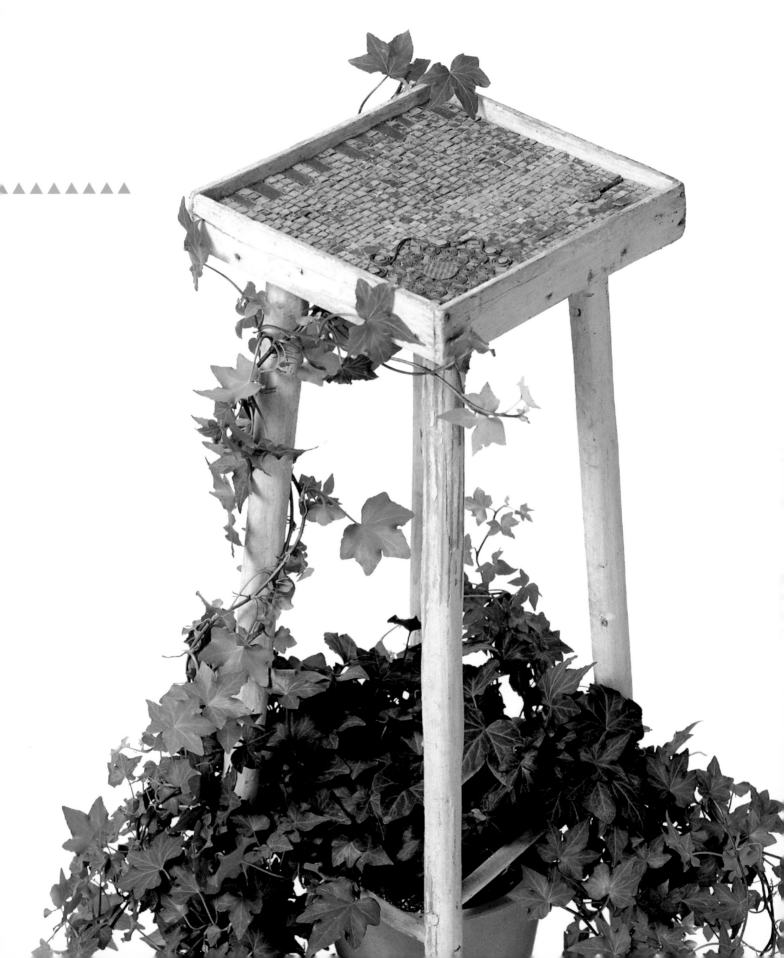

1

With tin snips, cut from the copper approximately 650 roughly 1/4-inch -square (6 mm) pieces, and set them aside. From the red tin shingle, cut nine rectangles to approximately 1 x ¹³⁄₁₆ inches (2.5 x 2 cm).

2

Pick a corner of the stand top's surface to use for your flower design, and measure and mark it off with a 3½ inch (8.8 cm) square. Set the stand in front of you so that the marked area is in the lower left-hand corner. Starting at the top of the side opposite the section you've marked off, position one of the tiny copper squares with the greenish side face up flush with the corner; remove it, spread a small amount of glue on the area, then glue the square in place. Working toward you down the side, position a single row of alternated squares and rectangles flush with one another and the surface edge. Keep the pattern of alternation as balanced as possible, with one or two squares between rectangles. Attach all squares with their greenish side face up, and all rectangles with the red or rust-colored side face up. When you've found a pleasing order, glue all pieces in place.

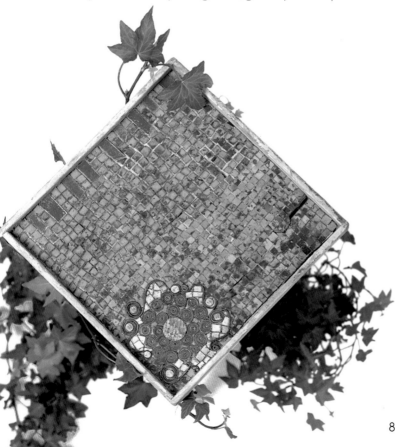

3

Next to the first square you glued in place, position and glue squares flush with one another and the surface edge to form a horizontal row along the top side of the surface. Working toward you, repeat this process until all surface area except the marked-off space is covered.

4

Within the uncovered surface area, center and sketch a rough design for your flower and its curlicue "border." The flower shown has a ¾ inch (1.9 cm) center (trace a penny's circumference to get the right size); petals formed by two concentric rows of ¹³⁄₁₆-inch-diameter (2 cm) and slightly smaller circles. Pieces forming the curlicue border are varied shapes and lengths. Cut a corrugated copper circle for the flower's center; position and glue it to the surface.

5

Cut the light-gauge copper wire into 20 to 25 pieces 1 to 2 inches (2.5 to 5 cm) long. Use your fingers or small pliers to create 22 or so small, tight, flat coils of roughly the same diameter. When each coil is formed, press it against a firm, flat surface to help flatten it evenly. Arrange these in two concentric rows around the glued center to find the best pattern. When you're staisfied, glue the coils in place.

6

From the remaining wire, cut three or four 2- to 4-inch-long (5 to 10 cm) pieces. Fashion them into pieces with loose-coiled ends that match your curlicue border design. Following the photograph, arrange these around the flower, with some of their curves brushing up against the penciled perimeter of the marked-off area. Hammer in a few bright copper tacks through openings in the end coils.

7

Fill in remaining uncovered surface area outside the design with leftover squares of copper gutter. (You may need to cut a couple of pieces "to order" to fill in corners or odd gaps.) From the yellow tin shingle, cut roughly 1/4-inch-square (6 mm) pieces "to order," to fill in uncovered area within the design. Glue all pieces in place, and let the finished mosaic dry overnight before using the stand.

METALLIC AZTEC EARRINGS AND PIN

DESIGNER: CAROLYN POTTER

Glowing colors and simple geometries stunningly complement each other in this unusual set of jewelry. Deceptively simple to make, this wearable trio will surely elicit questions as to where you bought them when you don earrings and pin for a night on the town.

What You Need

2-oz (56 g) block black polymer clay

Metallic powders for polymer clay (antique gold, red, blue, violet, gold-bronze, and silver)

Small bottle of clear lacquer or acrylic water-based gloss varnish for polymer clay

One 1½ inch (3.8 cm) sterling silver metal pin backing

2 sterling silver earring backings (approximately ½ inch [1.3 cm] diameter)

Pasta machine (optional)

Glass jar with smooth sides (optional)

2 pieces of ⅜-inch-thick (9-mm) model board, or 4 popsicle sticks (optional)

Ruler

Craft knife with standard-sized blade

Cotton swabs

Sewing needle or other tool with sharp point (for sketching on clay)

Manila folder

Oven

400- and 600-grit wet/dry sandpaper

Small dish of water

000 steel wool

Small paintbrush

1

Condition the clay by rolling it between the palms of your hands. (If you put it in your pocket first, your body heat will warm it up and make it easier to work with.) Once you can make a snake and fold it back on itself without the clay cracking, it is ready to work with. As it grows softer, roll it into a ball and pinch the ball until it is fairly flat (not thicker than $1/4$ inch [6 mm]).

2

If you have a pasta machine, you can keep conditioning the clay with your machine until it looks and feels like soft leather. To do this, set your pasta machine to its highest setting (for thickest extrusions) and run the flattened clay through; then set the machine to its lowest (for thinnest extrusions) setting, and run the clay through again. Repeat this process, or put the clay through 10 times at the thinnest setting (folding it back on itself and putting it back through each time) about 10 times until the clay looks and feels like soft leather. (Note: If the clay crumbles, you are putting the clay through too thick or the setting is too high; fold [do not roll] the clay into a thicker piece.) Once the clay is sufficiently soft, fold the clay over several times; set the pasta machine on its lowest setting, and pass it through one last time. The clay should be approximately $1/8$ inch (3 mm) thick.

3

If you don't have a pasta machine, simply use a smooth glass jar to roll the clay to an even thickness. Don't use a rolling pin or any other kitchen utensil that you plan to use with food in the future. To get the even thickness you would achieve with a pasta machine, place two thin pieces of wood or two popsicle sticks on either side of the clay and roll the bottle on top of the wood.

4

Following the photograph, create on paper geometric patterns for your design; place them on the clay. Using a ruler and craft knife, mark and cut out the base shape for your pin and earrings. Set these aside for now. Cut the remaining clay into long $1/4$-inch-high (6 mm) strips. Use a cotton swab to brush the top surface of each strip very lightly with metallic powders. Only the first layer of powder will stick; any excess will fall off. Discard used cotton swabs.

5

Use the sewing needle to sketch the big color areas of the design onto the base. Use the craft knife to cut tiles from the $1/4$-inch-high (6 mm) strips to fit into the design. Most tiles will be approximately $1/8$ inch (3 mm) thick. When the mosaic is complete, roll the craft knife's handle or a smooth glass jar over the surface.

6

Bake the finished pieces on a manila folder in the oven at 265° F (130° C) for 20 minutes. Because polymer clay hardens as it cools, the clay will still be flexible when you take it out of the oven. You can place a book on the pieces after they come out of the oven to keep them flat, if desired.

7

Working with one piece at a time, sand the backs and sides of the pin and earrings gently with fine 400- and/or 600-grit wet/dry sandpaper to clean up the edges. Rub a small piece of 000 steel wool over the back and side surfaces. Don't sand the fronts of the pieces, as this will rub off the metallic powders.

8

With a small paintbrush, coat the mosaic surfaces with clear varnish, and let the varnish dry completely.

9

Use cyanoacrylate glue to attach backs to the pin and earrings. Allow the glue to dry thoroughly before wearing the jewelry.

Mosaics On A
Grand Scale: THE WATTS TOWERS

*M*aking mosaics with materials such as metal, stone, and glass often requires more planning and time than making mosaics with paper, fabric, and other soft materials. Creating massive mosaicked structures using hard materials—such as Simon Rodia's famous Watts Towers in South Central Los Angeles—requires a rare and focused vision.

Begun in 1921 and completed in 1955, the Watts Towers are reportedly the largest building built by a single human being. Rodia, an Italian immigrant, built the 100-feet-high (3 km) towers from the ground up—without machines, scaffolding, or (perhaps most impressive) written plans. Many different techniques were used to create different parts of the Towers. The basic construction used steel skeletons or supports wrapped in wire mesh and covered with a strong, dry mortar; the mesh and mortar hardened to form a concrete. As if this alone weren't a truly awe-inspiring feat, Rodia then composed mosaic designs for each section, and pressed into the mortar tens of thousands of individual ornaments in a staggering array of natural and man-made materials, colors, shapes, and sizes. (The pique assiette exterior is comprised solely from found objects and discards, and is said to incorporate hundreds of rocks; pieces of marble and grinding wheels; wrought iron, scrap steel, and cooking utensils; 6,000 shards of colored bottle glass; dozens of mirrors; 10,000 seashells of different types;

15,000 glazed ceramic tiles; 11,000 pieces of pottery, broken and whole; and other miscellanea such as bits of linoleum, telephone insulating wire, and more.)

Like the works of many visionaries, Rodia's Towers have stirred up great controversy in their time. The City of Los Angeles' concerns about the Towers' structural soundness and safety prompted talk of demolishing the Towers in the 1950s; the suggestion met with hot cries of protest from L.A. residents and art lovers worldwide. Fervent debate led to a 1959 hearing, which in turn led to a widely publicized and attended "load test" performed later that year.

Sustaining a pressure pull of some 4.5 metric tons, the Towers held their ground. A little controversy still surrounds them, albeit more amicable and intellectual than the first— whether they are architecture, folk art, or assemblage is a matter of ongoing discussion among experts. All labels aside, they are a magnificent testament to artistic freedom and human expression.

SUNBURST JEWELRY BOX

DESIGNER: CATHERINE DELGADO

This box's fresh mix of cerulean blue, glowing yellow, and white calls up images of a whitewashed Mediterranean village by the sea on the sunniest of days. Sophisticated in a way that only the simplest things can be, it's great for storing jewelry, small accessories, or little keepsakes.

What You Need

Wooden box with hinged top (cigar box), 7 x 11¼ x 3 inches (17.5 x 28.1 x 7.5 cm)

82 ¾-inch-diameter (1.9 cm) iridescent glass "buttons" (81 blue, 1 yellow)

1 sheet bright yellow stained glass, 12 x 12 inches (30 x 30 cm)

1 sheet iridescent blue stained glass, 12 x 12 inches (30 x 30 cm)

Ceramic tile adhesive

Masking tape

1 cup (224 g) white sanded grout (unmixed)

Safety glasses

Glass nippers

Plastic container for mixing grout

Plastic knife or palette for mixing grout

Float

Paintbrush (small)

Latex gloves

Sponge or cloth

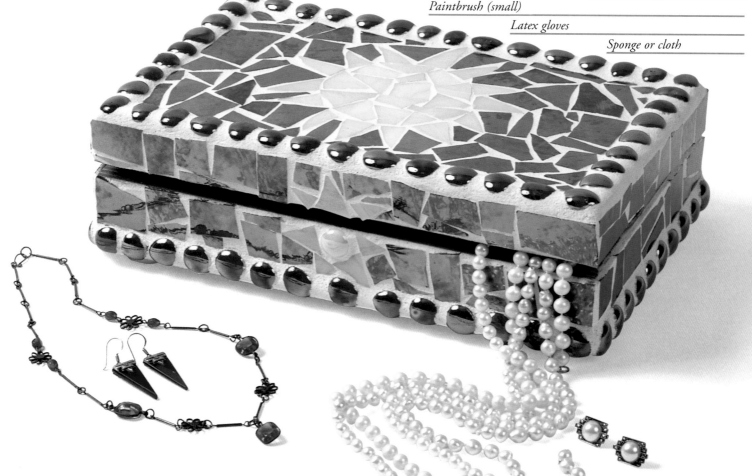

What You Do

1.

Position blue glass buttons around the perimeter of the box top, flush with the top's outside edge and each other. Apply a thin, even layer of adhesive to the back of each piece, and attach them to the box top.

2

Using the photograph as a guide, draw a rough sun design centered on the box top. The sun design shown has a 3¼-inch-diameter (9.4 cm) center, with rays approximately 1 inch (2.5 cm) long from the base to the triangle's longest point.

3

With glass nippers, cut the yellow glass into approximately 12 small geometric shapes no bigger than 1 inch (2.5 cm) on any side. You'll need roughly triangular pieces for the sun's rays (measurements in step 2); a combination of roughly square, rectangular, and triangular pieces will make up the sun's center. Position the pieces with approximately ¼ inch (6 mm) gaps between them to fill in the sun design. Try different arrangements to find the one that works best, then glue the glass pieces to the surface accordingly. As with following arrangements of glass pieces, you may need to cut a small piece or two "to order," to fill in any odd spaces.

4

Next, cut the blue stained glass into pieces of similar shapes and sizes (some can be larger, if you prefer) as those you used to create the sun's center. (For a box this size, you'll need 50 to 60 pieces.) Positioning them ¼ inch (6 mm) or so apart from the glass-button border, the edges of the sun's rays, and each other, arrange the pieces in a pleasing pattern to fill in the top's remaining surface area. Again, it's best to play with different arrangements to discover an optimal pattern. When you're satisfied with their placement, glue the pieces onto the box top. Allow the glue to dry for 30 minutes.

5

Turn the box on its hinged back side to work on the front.

Position the yellow glass button on the box's bottom half, centered and aligned with the finished sun design on the box top, and flush with the edge; glue it in place. This will serve as the center of the small sun design. Roughly sketch (or eyeball) a design for rays; the seven rays shown have base widths and lengths (from the base to the triangle's longest point) ranging from ¼ to ¾ inches (6mm to 1.9 cm). You should have a few rays on the bottom half of the box, surrounding the glass button, and a couple on the top half. Cut yellow glass into small triangles to roughly match the rays' triangular shapes, and glue them in place. Next, glue a row of blue glass buttons ¼ inch (6 mm) apart and flush with the bottom edge of the front side's bottom half. Follow step 4 to fill in the front side's remaining surface area.

6

Omitting the sun design, follow the same process you used for the front of the box to complete the remaining three sides, allowing each to dry for 30 minutes before beginning the next. When all sides are finished, allow the box with glued glass pieces to dry for 24 hours.

7

Before grouting, mask the insides of the box to protect them. Working in small sections, use a float to spread and smooth mixed grout over the surface so that all uncovered spaces (between cut glass pieces, and along the box's edges where there are no glass buttons) are filled. Wear gloves, and use your hand to apply grout along the glass-button borders; spread enough grout between buttons so that they appear to be spaced ¼ inch (6 mm) or so apart. Let each grouted area sit for 15 or so minutes, then use a sponge or damp cloth to remove excess grout; after another five minutes or so, remove any remaining excess traces of grout.

8

Let the grouted box sit for an hour, then buff the surfaces with a cloth. Allow the finished box to dry overnight.

RUSTIC WELCOME SIGN

DESIGNER: JEAN TOMASO MOORE

▲▲

No matter what language you say it in, the sentiment's one of the best going. Fixed on a nice door or gate, this welcome sign invites kith and kin with a down-home charm that's hard to beat.

What You Need
..

1 pine board, 4 feet by 8 inches (1.2 m x 20 cm)

1 pt. green semigloss latex paint

A couple of sheets of inexpensive drawing paper at least 11 x 30 inches (27.5 x 75 cm)

Letter stencils (optional)

Carbon paper (optional)

Assorted hardware fasteners, including:

small screws and finishing nails; galvanized roofing nails with $^{13}/_{16}$-inch -diameter (2 cm) heads; black metal carpet tacks with $^{7}/_{16}$-inch- diameter (1.1 cm) heads; $^{1}/_{4}$-inch-diameter (6 mm) metal washers; and standard-sized white thumbtacks

Wood glue

A 3/4-inch-diameter (1.9 cm) tree branch approximately 5 feet (1.5 m) long

Two $^{1}/_{4}$- or $^{1}/_{2}$-inch-diameter (5.6 or 1.3 cm) metal eye hooks

2 ft. (60 cm) medium-gauge picture-hanging wire

Hand-held electric drill with drill and screwdriver bits

Paintbrushes (a range of sizes)

Ruler

Pencil

Hammer

Handsaw

NOTE: *To form some of the interior borders between the sign's outside white-thumbtack border and the border of washers and galvanized roofing nails immediately surrounding the WELCOME design, this designer used a combination of different types of nails, thumbtacks with plain and decorative heads, and screws in different materials. To replicate this sign's color scheme, you'll need fasteners whose heads look gold, brassy, and black. Or follow your imagination and mix it up a little.*

1

Cut the pine board into two pieces, each 7¼ x 23½ inches (18.1 x 58.7 cm). Align the boards face to face and secure them to one another from the back with a few screws. (Note: When installing any screws, first drill a pilot hole; then install the screw through it into the board. This will prevent the wood from splintering.) Apply one or two coats of paint to all surfaces of the joined boards. Allow paint to dry completely before moving on to the next step.

2

Place the painted board on a piece of paper and trace its perimeter. Remove the board. Centering letters within the traced area, freehand draw or use stencils to individually outline each letter of the word WELCOME in a blocky style. The letters on the sign pictured are 4¼ inches (10.6 mm) high, positioned approximately a ½ inch (1.3 cm) apart from one another and 1-½ inches (3.8 cm) from all four sides of the board. Use carbon paper and a pencil to transfer the design onto the painted board.

3

Next, along the outlines of all letters, center roofing nails on the lines you've drawn, making sure that adjacent nails are aligned, and hammer them in so that the heads are flush with the board. Fill in the letters by hammering closely positioned carpet tacks into the board (a ⅟₁₆ inch [1.5 mm] or smaller overlap of tack heads is fine ...it's rustic, after all!).

4

Fill in spaces between the letters with carpet tacks. Hammer tacks close together and into the board with roughly consistent depth. Overlapping nail heads and/or spaces between nails are fine. Nail a single row of tacks around the outside perimeter of the letters (and spaces filled by tacks that continue this perimeter between letters). Glue washers with their sides flush with the tacks and each other in a single row around the tack border. Allow to dry completely. Nail a single carpet tack through the hole in each washer into the board.

5

Around the outside perimeter of the board's face, firmly press a row of white thumbtacks into the board to form an outside border. Fill in remaining surface space with assorted fasteners symmetrically arranged.

6

Measure and cut the tree branch into two pieces approximately 23½ inches (58.8 cm) long, and two pieces approximately 10½ inches (26.3 cm) long. Apply one or two coats of paint to each piece, and let them dry. Use small screws and finishing nails to attach them to each other to form a frame that will fit snugly around the sign's perimeter, and to attach the frame to the sign.

7

Install two eye hooks 14 or so inches (35 cm) apart on the back of the sign. Wrap doubled wire tightly between and around the eye hooks to form a hanger, and hang the sign in your chosen spot.

FAUX STAINED GLASS WINDOW

DESIGNER: LINDA NALL

There's nothing quite like the jeweled glow of sunlight filtering through stained glass, throwing gentle shafts of light across the floor ... And while we can't all be master glass artisans, this technique lets anybody with a little time and effort create a stained glass window as rewarding as the real thing. This designer salvaged a window whose days were nearly up and turned it into a thing of beauty.

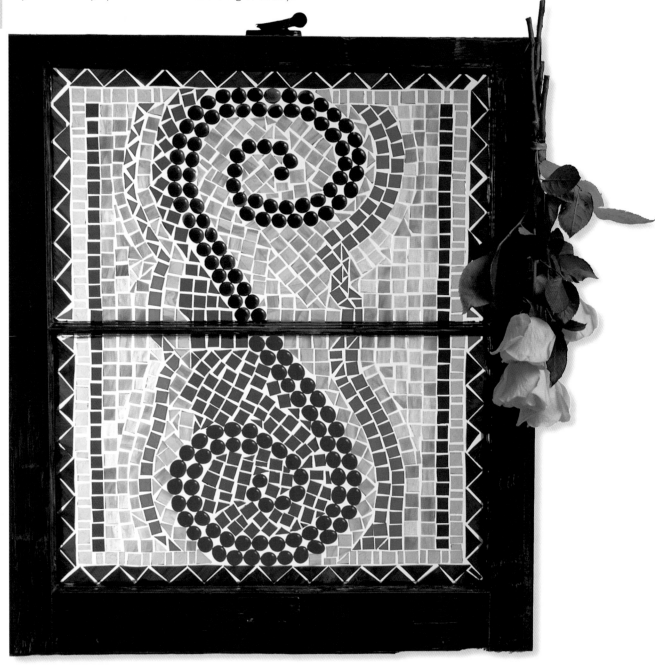

What You Need

Glass window, 24 x 28 inches (60 x 70 cm) with 2-inch-wide (5 cm) wood frame

Paint

150 ¾-inch-diameter (1.9 cm) glass "buttons" (75 blue, 75 purple)

1 sheet purple stained glass, 12 inches (30 cm) square

3 sheets green stained glass—1 pastel green, 1 dark green, 1 bright green, each 6 inches (15 cm) square

1 sheet pink stained glass (mottled with different shades),12 inches (30 cm) square

1 sheet bright blue stained glass, 6 inches (15 cm) square

Clear silicone sealant

Paintbrushes (a range of sizes)

Tape measure

Pencil

Safety glasses

Glass nippers

Running pliers (optional)

NOTE: *Because your home's optimal location for a stained glass window may not require a window this size or shape, you'll need to adapt the following techniques and design to suit your window's size, shape, and composition.*

What You Do

1

Apply two to three coats of paint to the wood frame. Let the paint dry completely.

2

Determine which side of the window will face into the room in which will be installed. Place the window with this side face up on a work surface. About 4½ inches (11.3 cm) down from the top of the glass, measure in 9½ inches (23.8 cm) from both vertical sides of the glass, and mark; about 4½ inches (11.3 cm) up from the bottom of the glass, measure in the same distance from both sides and mark. These two points indicate placement positions for the single glass buttons that form the "tail" of the mosaic's central curlicue design. *(Note: For all adhesion required by this project, apply a small amount of silicone sealant to the area*

of glass directly below the glass piece being attached, and gently press the glass onto the sealant.) Glue a purple glass button on the upper mark, and a blue one on the lower mark. Using these as starting points, position (but don't glue yet) double rows of glass buttons—purple on the upper half of the glass, and glue on the lower half—to form the curlicue pattern shown in the photograph. Experiment with placement to get the patterns as symmetrical as possible, then dab glue on the glass in the button locations and attach the buttons. Let them set for 24 to 48 hours. *(Note: From here on, let glued glass set for 24 to 48 hours after attaching all pieces each color.)*

3

With glass nippers, cut from the sheet of purple stained glass 90 to 100 small triangles with no sides longer than 1½ inches (3.8 cm) . Position and glue a single row of triangles around the outside perimeter of the glass, with their sides flush with the edge of the glass and adjacent angles meeting. Position a second row of inverted triangles inside the first, with ⅛ inch (3 mm) space between the two rows. Glue them in place and let them dry for 24 to 48 hours.

4

From the sheet of pastel green stained glass, cut ½ inch (1.3 cm) squares and smaller rectangles. Leaving a small space between their edges and the row of triangles you just attached, position alternated squares and rectangles ⅛ inch (3 mm) or so apart inside the row of triangles. Cut ½ inch (1.3 cm) squares of purple glass. Leaving a small space between them and the the pastel green border, place and glue a single vertical row of purple glass squares inside the pastel green border on each side of the glass.

5

From the sheets of dark green, bright green, and bright blue stained glass, cut small geometric shapes. Following the photograph, position bright and dark green pieces to fill in and surround the curlicue design, echoing its shape. Use blue pieces to create a slim border, or "outline," for the green pieces. Cut the pink glass into approximately ½ to 1 inch (1.3 to 2.5 cm) squares. Position and glue them to fill in the remaining glass surface area; cut small pieces "to order" to fill in final corners and oddly shaped gaps. Allow the finished mosaic to dry for 48 hours before installing.

ANASAZI PENDANT

DESIGNER: CAROLYN POTTER

▲▲▲▲▲▲▲▲▲▲▲▲▲▲▲▲▲▲▲▲▲▲▲▲▲▲▲▲▲▲▲▲▲▲

With colors and shapes inspired by traditional Anasazi shell pendants, this splendid necklace piece evokes the mystery and ritual of ancient cultures. Its rich reds and turquoises make it a wonderful accent for a favorite black blouse or sweater.

What You Need
...

2 x 2 inch (5 x 5 cm) scallop or clam shell for use as a mold

Polymer clay (1/2 block champagne/beige; 1/4 block black; 1/4 block royal blue; 1/4 block light turquoise; 1/4 block sky blue; 1/8 block turquoise and light blue mixed; 1/8 block orange)

Red oxide acrylic paint

1 piece of leather cord, long enough to hang around neck at desired length

Aluminum foil

Craft knife with standard-sized blade

Ruler

Pasta machine (optional)

Smooth glass jar (optional)

2 pieces 3/8-inch-thick (9-mm) modeling board, or 4 popsicle sticks (optional)

Sewing needle, or other sharp, pointed tool (for sketching on clay)

Tapestry needle, or other large punch tool

Manila folder

Oven

400-grit wet/dry sandpaper

Small dish of water

Damp paper towel

000 synthetic steel wool

600-grit wet/dry sandpaper

Muslin buffing wheel or denim, for polishing

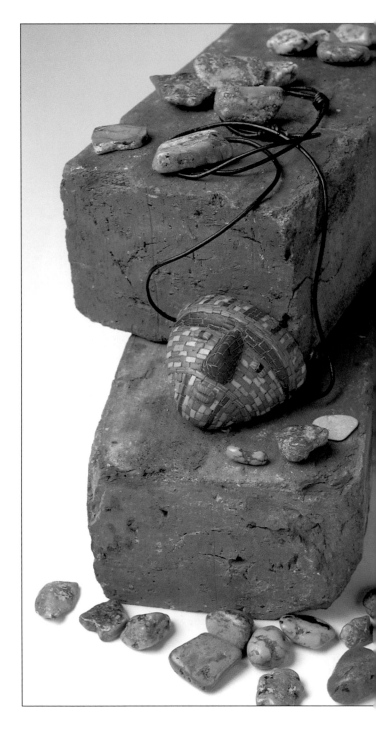

What You Do

1

Find a scallop or clam shell approximately 2 x 2 inches (5 x 5 cm) to use as a mold for your mask. A shell with ridges will give the back of the final mask the look of a real shell. Cover the shell with aluminum foil, pressing the foil against the contours of the shell. Wrap the excess foil around the back of the shell.

2

Condition ½ block of champagne/beige clay by rolling it between the palms of your hands. (If you put it in your pocket first, your body heat will warm it up and make it easier to work with.) Once you can make a snake and fold it back on itself without the clay cracking, it is ready to work with. As it grows softer, roll it into a ball and flatten it into a disk shape about ⅜ inch (9 mm) thick. Lay the clay disk over the shell and use the craft knife to trim it to a mask shape. Do not allow the clay to wrap around the back of the shell—if you do, you may not be able to remove the final mask from the shell after baking.

3

Make a 3/8 x 1½ x ½ inch (9 mm x 3.8 cm x 1.3 cm) rectangle out of the beige clay. Bevel the back and side edges with the craft knife or ruler. This shape will form the forehead. Apply the shape to the mask, positioning the thick edge down to form the eyebrow. Make a triangular shape out of beige clay to use as the nose. Apply the shape to the mask, positioning the top tapered edge just below the eyebrow. Pinch the triangle into the desired shape.

4

Flatten each color of polymer clay and pass it through the pasta machine at the thickest setting. If you don't have a pasta machine, roll the clay between two pieces of ⅜-inch-thick (9-mm) modeling board or four popsicle sticks (two above, two below) to achieve an even thickness. Next, cut each color into ¼-inch-high (.6 cm) strips. Use the craft knife to slice off ⅛-inch-thick (3-mm) tiles (tesserae) to make the mosaic.

5

With the sewing needle, sketch the mask design into the beige clay mask. Fill in the design with the tiles. Alternate the colors of blue to create a more realistic turquoise look. Use orange and black tiles to make eyes, and orange tiles to make lips for the mouth. Once the design is complete, roll the smooth handle of the craft knife over the tiles to adhere them to the mask.

6

Use the tapestry needle to poke a hole on either side of the forehead at the top of the mask. If the holes are too low, the mask will be top-heavy and will flip over when it is hung on the cord.

7

Place the mask on the manila folder in the oven and bake at 265° F (130° C) for 25 minutes. The heat will not hurt the shell. Once the mask has cooled, remove it from the shell mold and take off the aluminum foil.

8

Sand the sides of the mask with the 400-grit wet/dry sandpaper in a small dish of water (to avoid breathing the dust) to round the edges. Use a damp paper towel to rub the red oxide acrylic paint into the tile cracks on the front of the mask, and onto the back side of the mask. Wipe off the excess paint and let the mask dry. The red oxide will give the mask an antique look.

9

Sand the mask again with 000 synthetic steel wool, then with 400- and 600-grit wet/dry sandpaper in water. Polish the mask against denim or a muslin buffing wheel (this process will also remove any excess paint). Thread the mask onto the leather cord to wear as jewelry.

CHAPTER SIX:

BUTTONS, BEADS, & BITS

If you frequent flea markets or have your own stash of bits of old costume jewelry and sewing sundries such as buttons and sequins, you know: There's something wonderful about simply sifting through a box filled with beads, bits of glittering rhinestone and pearls, small unusual trinkets and charms, and buttons in all different shapes, sizes, and colors ... Though their textures are different than sand, they make a similar, marvelous, whispery music full of possibilities ...

On the following pages you'll find chances to sift to your heart's content—and, better yet, to create unusual functional and decorative mosaics that are sometimes playful, sometimes classic, and always tons of fun to make.

WHIMSICAL CURIO CABINET

DESIGNER: ELLEN ZAHOREC

▲▲▲▲▲▲▲▲▲▲▲▲▲▲

Refreshingly quirky, this cabinet's wonderland appeal makes it a playful display case for bright knickknacks or a "secret treasures" storage place that will thrill kids. Or just set it on a tabletop or shelf and let it work its own merry decorative magic.

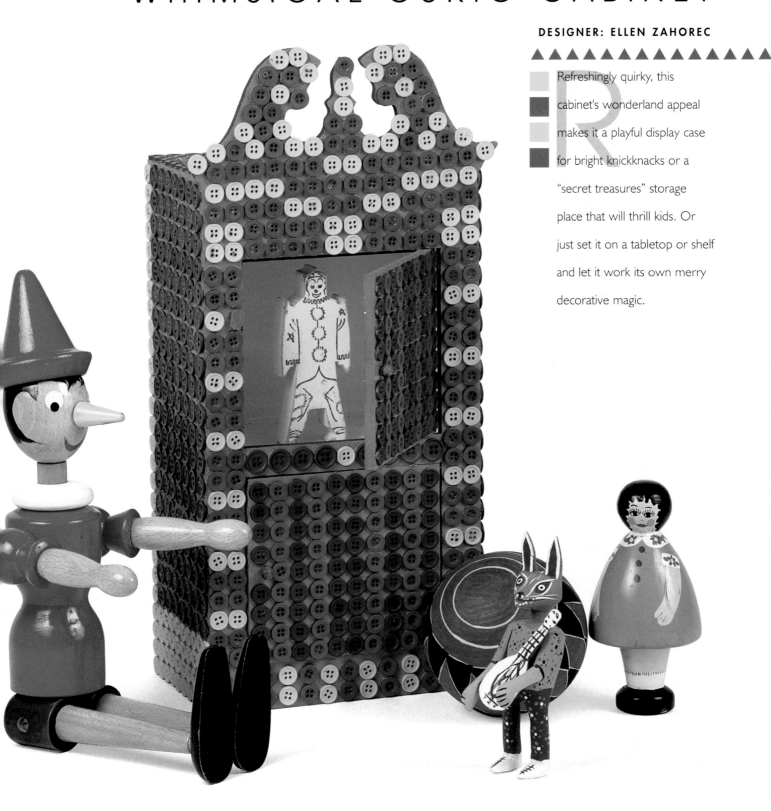

What You Need

Wooden curio cabinet, 4½ x 7 x 13 inches (11.3 x 17.5 x 32.5 cm)*

Acrylic paint (pale aqua and orange)

900 or so plastic buttons in sizes ranging from ¼ to ½ inch (.6 mm to 1.3 mm) in diameter (yellow, red, pale purple, and bright purple)

Paintbrushes (medium, extra small)

Sponge

Acrylic clear gloss

NOTE: *The dimensions given for the curio cabinet pictured do not include the decorative embellishment at the top of its front side, which rises three inches above the cabinet's top. If you're working with a cabinet that's bigger or smaller, has a different shape, or includes different features—the number of doors, for example— you'll need to adapt the materials list and design accordingly.*

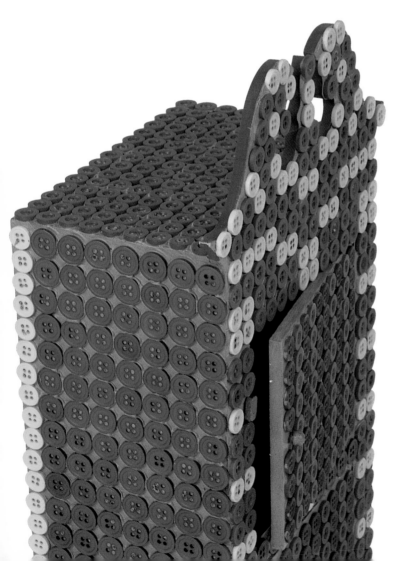

What You Do

1

For this project, thick acrylic paint applied to the cabinet's wood surface also serves as fixative to hold the buttons in place. Since you'll paint a small area (about ¼ of a side) at a time, fixing the buttons in place as you go, it's best to plan the cabinet's overall button pattern before starting to work. Depending on the general shape of the cabinet you choose and the composition of any features it might include, you can either follow the symmetrical design in the photograph or create your own mosaic design. Experiment with patterns by arranging buttons flush with one another on the cabinet before painting it.

2

Apply a thick, even layer of aqua paint to a small section of the cabinet's front side. Working in horizontal or vertical rows, left to right, so that you don't "paint yourself into a corner," arrange red, yellow, and purple buttons according to the design you've planned. Gently place buttons into the paint with your fingers, then use the pointed end of an extra-small paintbrush to press them down into the paint.With a damp sponge or cloth, wipe away traces of paint that may seep through the buttonholes. Continue this process, painting and fixing buttons to a small area at a time, to cover the the cabinet's front side. Allow the paint to dry overnight before starting work on the next side, to ensure the buttons are fixed in place.

3

To complete the mosaic on all sides of the cabinet, use this method on one side at a time, allowing each side to dry before starting work on the next. Paint the side walls orange, and decorate them with green and yellow buttons; for the top, use aqua paint with red buttons. (The back of the cabinet is not decorated; if you choose to give yours a mosaic design, choose paint and button colors that work with the overall design.) Let the last side dry overnight before finishing.

4

Apply a light coat of acrylic clear gloss to finish. Allow the finished cabinet to dry overnight.

PEARLED DECANTERS

DESIGNER: BARBARA COX

The bejeweled, old-world charm of these pearled decanters makes them a dainty, delightful addition to dresser and bureau tops. They make great replacements for less-than-lovely plastic scent and lotion bottles ... Or make a whole set and give it to a friend who needs a little Duchess in her day.

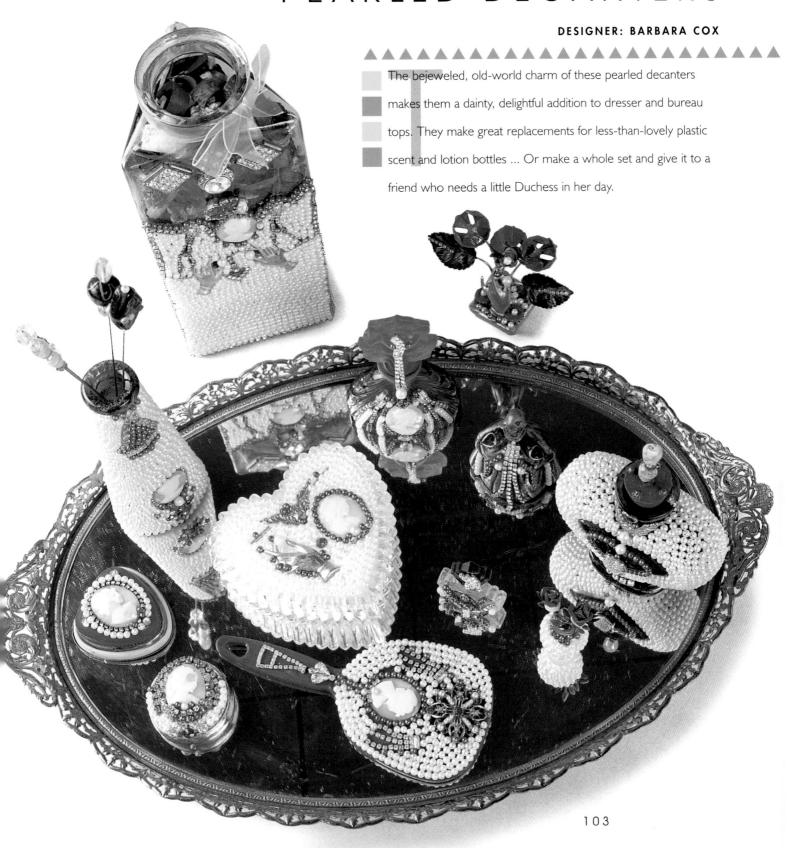

What You Need

Small glass decanter with smooth surface*

Acrylic paint (metallic "gold leaf")

1 cameo, 1¼ x 1 inches (3.1 x 2.5 cm)

50 oblong gold-plated beads, ¼ inch (6 mm) long

85 clear rhinestones, 3/16 inch (5 mm) square

30 oblong, faux-pearl beads, ¼ inch (6 mm) long

525 round, white faux pearls, 3/16 inch (5 mm) diameter

6 colored rhinestones, 3/16 inch (5mm) square

8 round, gold seed beads, ⅛ inch (3 mm) diameter

Cyanoacrylate glue

Paintbrush (extra small)

Ruler

Small bottle of clear acrylic nail polish with brush

NOTE: This unusual triangular perfume decanter is 3¾ x 4 x 1 inches (9.4 x 10 x 2.5 cm). Plain glass decanters, which you can find at flea markets or craft stores, come in a dazzling range of sizes and shapes. Since personal taste—and shopper's luck—will dictate which one you choose to use for this project, you may need to adjust materials amounts and design patterns.

What You Do

1

With a tiny paintbrush, apply a coat of metallic gold paint to the decanter's top and the rim of the vessel's neck. Let the paint dry completely before attaching any beads or rhinestones.

2

Use a ruler to find the center of the front side of the bottle. Position and glue the cameo to the bottle.

3

Place and glue one row of the ¼ inch (6 mm) oblong gold beads end to end, around the bottle's sides, along their bottom edges. On the bottle's front side, center, place, and glue the ⅛ inch (3mm) clear rhinestones above and flush with the bottom row of gold beads. Arrange and glue the ⅛ inch (3mm) clear rhinsetones in an arc around the top half of the cameo's perimeter so that they meet the figure's shoulders on both sides.

4

Use single rows of faux-pearl and gold ¼ inch (6 mm) oblong beads placed alternately and end to end to create vertical outlines of each side of the bottle. (These will differ depending on the shape of your decanter; if you're using a spherical bottle, this step won't apply.) On the bottle's front side, position and glue a row of 3/16 inch (5mm) clear rhinestones flush with and inside the beaded outlines, to create a second "outline". Glue another row of 3/16 inch (5 mm) clear rhinestones inside and flush with the first. Join these rhinestone outlines at the top of the bottle's front side by placing a small horizontal row of 3/16 inch (5 mm) clear rhinestones between them. Place and glue a single vertical row of ¼ inch (6 mm) gold beads flush with the inner rhinestone outlines on both sides of the bottle's front, to create a slim border.

5

Fill in all remaining spaces on the decanter's surface with 3/16 inch (5mm) round faux pearls, placing and gluing them as close together as possible.

6

Use a colored rhinestone (green, or the color you prefer) to accent the cameo. Select a few more to use with 3/16 inch (5mm) clear rhinestones and tiny gold seed beads to decorate the decanter's top or stopper. Allow the fully decorated decanter to dry for 24 hours.

7

Brush an even coat of clear acrylic nail polish over the beaded mosaic's surface. Let it dry completely before using.

SEQUINED ZEBRA-STRIPE FRAME

DESIGNER: JEAN TOMASO MOORE

This dramatic mosaic frame surrounds a favorite photo or picture with the wink and glitter of sequins set in an exotic design. Or use the design to create a mirror border and ask, Mirror, Mirror, On The Wall ... who's the wildest of them all?

What You Need

Mirror, 28⅛ x 28¼ inches (70.3 cm x 70.6 cm) with a 3½- inch-wide (8.8 cm) metal or plastic border

Approximately 6,000 large and small black and white sequins (or other contrasting colors)

Craft glue

Ruler

Pencil or chalk

Tweezers

Sponge

What You Do

1

Use a ruler and pencil or chalk to create the zebra-stripe effect by drawing diagonal lines approximately ¾ to 2 inches (1.9 to 5 cm) apart across the mirror's border. Making some of the stripes in "V" patterns will give the design more of an authentic zebra effect. This will create about 31 "stripes" on each side of the frame. (If you're adapting the design for a smaller or larger mirror with a narrower or wider border, plan ahead to ensure that the the stripes' colors will alternate all the way around the border.) Mark the alternating stripes lightly in pencil to indicate which color sequins will go there.

2

With your fingers, spread a thin, even layer of glue onto a small area of the surface at one end of a stripe. Position the colored sequins you've assigned to that stripe on the surface; press them gently into the glue using tweezers. Clean excess glue from your fingers and tweezers with a damp sponge. Continue placing sequins across the stripe's surface until it is covered. Next, using sequins in the other color you've chosen, fill in the stripe above or below, slightly overlapping the edge of the first stripe you filled in.

3

Repeat this pattern around the frame surface.

FLEUR-DE-LIS FRIDGE MOSAIC

DESIGNER: TERRY TAYLOR

For centuries, the stately fleur-de-lis symbol—a conventionalized, ornamental iris—has been used in art and heraldry. No pomp and circumstance with this project, though. It's easy, great fun, and leaves you with a perky decorative note in your kitchen. Adapt it for children's designs, and it's a super-duper kid-pleaser.

What You Need

Colored flexible magnet sheets (red, yellow, gold, black)*

Sheet of clear acetate, 12 x 12 inches
(30 x 30 cm) (optional)

Scissors

Ruler

Craft knife

Hole punch (optional)

Erasable dry marker

NOTE: *This designer used sheets of colored flexible magnet, but you can substitute these by covering self-adhesive magnet sheets from a craft store with colored paper of your choice.*

What You Do

1

Enlarge the fleur-de-lis pattern to 12 inches (30 cm) square.

2

Copy the to-size pattern onto the sheet of acetate, or use the pattern as a guide to sketch the fleur-de-lis design onto your refrigerator with an erasable marker. If you opt for the acetate pattern transfer technique, secure it to the refrigerator with magnets of any sort.

3

With a ruler craft knife, measure and cut your colored magnet sheets to the following specifications: eight strips, each 1 x 10 inches (2.5 x 25 cm) (4 gold, 4 black); 38 strips, each ⅝ x 12 inches (1.6 x 30 cm) (14 red, 12 yellow, 12 black); 12 strips of gold, each ⅜ x 12 inches (9 mm x 30 cm); four 1¼-inch (3.1 cm) gold squares of gold; and four 1-inch (2.5 cm) black squares.

4

Cut the black and gold 1 x 10-inch (2.5 x 25 cm) strips into triangles with 1-inch (2.5 cm) bases. Begin to create your mosaic by positioning the black and gold triangles in an alternated sequence around the perimeter of the fleur-de-lis motif. You'll have a number of triangles left over to use in the next step.

5

Select the 1-inch (2.5 cm) black squares, and position one in each of the overall design's four corners. Finish the design around the outside border by positioning alternated black and gold triangles between the black squares. (You can punch holes in the black squares and discard the tiny black circles cut out, then punch holes in red and yellow scraps, save the tiny red and yellow circles, and position them inside holes in the black squares.) You will need to cut some black and gold triangles in half to fill in corner spaces.

6

Next, work on the red-and-yellow checkerboard border. Select all but one of the the red and all of the yellow ⅝ x 12-inch (1.6 x 30 cm) strips and cut them into roughly ⅝-inch (1.6 cm) squares. Position these as shown in the photograph to create the checkerboard effect.

7

Select the 1¼-inch (3.1 cm) gold squares and position one or more at each corner of the checkerboard or somewhere else. (Note: This is a good time to check and make sure that the design is roughly square, and to change its position on the fridge if its location doesn't satisfy you—later, there will be lots of small pieces to move.)

8

Select all but one of the black ⅝ x 12-inch (1.6 x 30 cm) strips, and cut them to create the outermost border for the mosaic design.

9

Now you can start to work on the mosaic's central design. Cut the remaining black ⅝ x 12-inch (1.6 x 30 cm) strip, and cut it into ¼-inch (6 mm) pieces (shape?). Position these on the inner edge of the fleur-de-lis motif. Using the remaining red strip, repeat this process.

10

Select the gold ⅜ x 12-inch (9 mm x 30 cm) strips and cut them into small squares; use these to outline the fleur-de-lis. You will have to make a number of cuts to create smaller squares and triangles as you work, to make the curves appear smooth. When you are happy with the fleur-de-lis shape, fill in the interior with gold squares.

11

Finish the background of the center square with ¼-inch (6 mm) rectangles and squares cut from the red ⅝ x 12-inch (1.6 x 30 cm) strips.

BEADED BASKET WALL DECORATION

DESIGNER: ANN MCCLOSKEY

▲▲▲▲▲▲▲▲▲▲▲▲▲▲▲▲▲▲▲▲▲▲▲

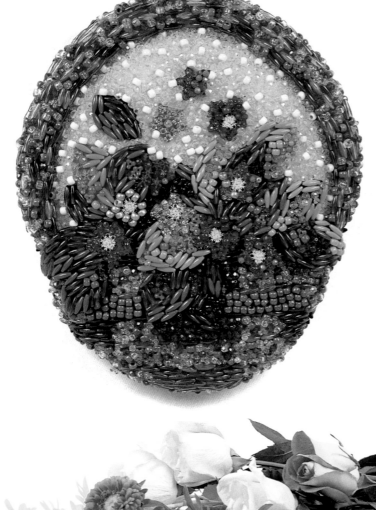

Placing this beaded bouquet in the front hall will ensure a bounty of sparkling blooms to greet your guests year-round. While the project's materials and steps are many, you'll be delighted with how easy and fun it is to create a beaded mosaic on fabric. If the bouquet of violets is your first attempt at this innovative crafting technique, the bets are high that it won't be your last.

What You Need

11 x 14 inch (27.5 x 35 cm) oval stretched canvas

Light loft quilt batting, at least 2½ x 2 ft. (90 x 60 cm)

1½ (135 cm) yards of peach felt

1 yard (90 cm) of brown felt

½ yard (45 cm) each of bright green, medium green, dark green, lavender, medium purple, and dark purple felt

Beads:

 8 shades of brown and golden brown

 2 shades of peach in round and pony

 5 shades of lavender in round and pony

 5 shades of medium purple in round and pony

 5 shades of dark purple in round;

 bright green in round, pony, and long;

 medium green in round, pony, and long;

 dark green in round, pony, and long

 yellow seed beads*

1 to 2 tubes of strong bond adhesive, for gluing beads

18-mm fancy gold bell caps, one for each flower center (nine, for this design)

Polyester stuffing

Scissors

Duct tape

Needle and thread

White chalk

Tacky glue

Ruler

Tweezers

Sawtooth hook

NOTE: *Beads come in many styles—this designer used three shapes, known as round, pony, and long beads. Ask your local craft store salesperson to assist you in selecting specific bead styles, or read the labels of packaged beads to determine the correct shapes.*

What You Do

1

With scissors, cut the quilt batting into a rectangle larger than the oval canvas. Pull the batting tightly around to the back of the canvas, making sure it is taut. Secure it to the back with duct tape.

2

Place the entire length of peach felt over the front of the batting and wrap it around to the back. Gather one section of peach felt at a time and use the needle and thread to tack it together until it is pulled over the cork stretcher bar on the back of the frame. Repeat this process until all the peach felt has been gathered and tacked all the way around the frame.

3

Cut the brown felt to fit the bottom third of the canvas, making sure you have enough felt to wrap around the back of the canvas. Mark the center point of the felt, then drop slightly lower than this point and make another mark with the white chalk, extending it into a straight line across the front and sides of the oval. Using the tacky glue, glue the felt to the chalk line in the front and on the sides. Wrap the felt around to the back of the oval and gather and tack it to the stretcher as you did with the peach felt.

4

Cut a second piece of peach felt to fit on top of the peach felt section that remains visible. Glue the second piece of peach felt over the first, butting it up to the edge of the brown felt, and tack it to the back. This second layer assures that the front surface will be level.

5

Decide how you will arrange the flowers and leaves in the basket design. You may want to have them spilling out of the basket for added visual interest and depth.

6

Cut simple flower and leaf shapes out of different colors of felt. This designer used various shades of purple and green. Using the tacky glue, glue some of the leaves onto the center, front, and sides of the basket. Overlap the leaves in the basket to create depth. Place and glue the felt flowers on top of the leaves, and add a few at the top to give a lighter feeling.

7

Use the ruler and chalk to mark off five or six lines about $1\frac{1}{2}$ inches (3.8 cm) wide on the brown felt. These will provide a guide for gluing on the beads.

8

To glue the beads onto the felt design, hold each bead in the tweezers as you place a dab of strong bond adhesive on one side of it, then place the bead onto the fabric. Begin beading the basket by gluing long brown beads along each of the chalk lines. Simply bead around any flowers or leaves that hang over the edge of the basket rim. Incorporate as many styles and shades of the brown beads as you like to create the color and texture of a basket. Each row will be different from the others. Bead only the front of the basket at this point; the sides will be finished later.

9

Outline the leaves with long, green beads, then fill them in with green beads in various shades and styles. Alternating dark green leaves and bright green leaves in the basket will help them stand out.

10

Before you begin beading the flowers, glue a gold bell cap to each flower center. Then, glue a cluster of yellow seed beads to the inside of the bell cap. Use round beads in various shades of purple and violet to finish the flowers, grouping light purples and dark purples together.

11

To make the felt basket handle, cut two lengths of brown felt, 5 x 32 inches (12.5 x 80 cm). Stitch the sides together to form a tube, leaving both ends open. Turn the tube inside out and stuff it with the polyester filling, leaving it loose enough to bend into a curved shape easily. The ends of the tube should reach around the oval and meet the rim of the basket on each side. Tuck the ends of the tube in and glue them down securely with tacky glue. Then, apply tacky glue to the underside of the felt tube and press it around the top of the oval frame to adhere. Let the handle dry completely.

12

In a random pattern, glue the peach beads to the background of the design, filling in the space between the basket of flowers and leaves and the basket handle. Use twice as many light, translucent beads as opaque beads. Glue them as close to the flowers, leaves, and basket handle as possible.

13

To bead the handle, use a full assortment of brown beads, evenly distributed from one end of the handle to the other. Glue them as tightly together as possible, and as close to the peach beads as possible. Be sure to glue beads around the sides of the handle as well.

14

Check the sides of the oval to determine where you need to place more beads, and glue on more beads where they are needed. Also, check to see if you need to add any more beads to leaves or flowers, or to fill in any gaps in the design.

15

When all the beads have dried completely, turn the piece over. Cut a piece of brown felt slightly larger than the back of the oval. Using the tacky glue, glue the felt down so that the sides just touch the stretcher bar. Trim off any excess material and allow the back to dry completely.

16

To hang the finished piece, center a sawtooth hook on the top third of the back of the oval. Hand stitch the hook in place securely and mount the project on a wall or hang with a satin ribbon.

The Pearlies:
WEARABLE MOSAICS FOR A GOOD CAUSE

road sweeper and rat catcher. There he was taken under the wing of hardworking produce traders known as "Costermongers" ("coster" being Cockney, or East End slang, for a type of large apple called a Costard). By all accounts, Costermongers were a tough—but caring—breed of folk. They set themselves apart from other traders by wearing "Flash Boy" outfits, trousers and waistcoats seamed with pearl buttons in mockery of jewels worn by the aristocracy of the times. They also took care of their own—if one of the gang was down and out, the Costers would take up a collection (known in Cockney as a "whip round") to help get him back on his feet.

Young Henry Croft was so taken with the lifestyle and look that he took his "Flash Boy" suit to the ultimate level, covering it from top to bottom in wild mosaic patterns of pearled buttons. Not surprisingly, he became an overnight local attraction, and began to put in fund-raising appearances for London's hospitals and churches. The trend caught on, with men from every London borough, who came to be known as Pearly Kings, following Henry's sartorial and charitable lead. The tradition has flourished. Today, families from all over England—including Pearly Kings, Queens, Princes, and Princesses—gather for parades and events to raise funds for good causes. They are as much an English institution as Big Ben, a good pint of bitter, beans on toast, or "bikkies and tea."

M osaics made with buttons, beads, and bits find their most spectacular incarnation in England's Pearlies, a group of folk who, to raise money for loads of different charities, create and don festive and flamboyant togs decorated mosaic-style with a breathtaking number of tiny pearl buttons.

The Pearly tradition's history is an intriguing one. In 1875, a 13-year-old lad named Henry Croft left the orphanage he was raised in to take work in an East End, London, market as a

Gallery

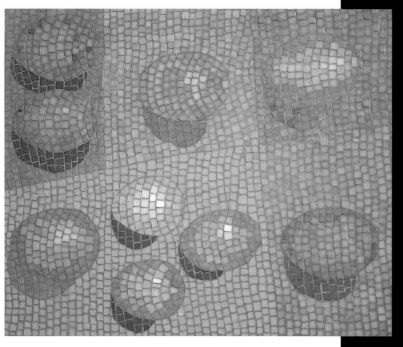

Above left: Emma Biggs, *Eggs*, 1995. Glass, 20 x 24 inches (50 x 60 cm).

Above: John Salvest, *Nothing Endures,* 1998. Site installation of paper (business cards), thumbtacks, painted sheathing, 10½ x 18½ feet (3.2 x 5.6 m). *Courtesy of New Museum of Contemporary Art, New York.*

Above right and below: Gary Drostle and Rob Turner, *Those Who Were Here Before,* 1998. Vitreous ceramic tile, floor 1.1 x 2.2 yards (1 x 2 m), stair panels 48 x ⅜ inches (120 cm x 10 mm). *Doncaster Community Arts Centre, Doncaster, England.*

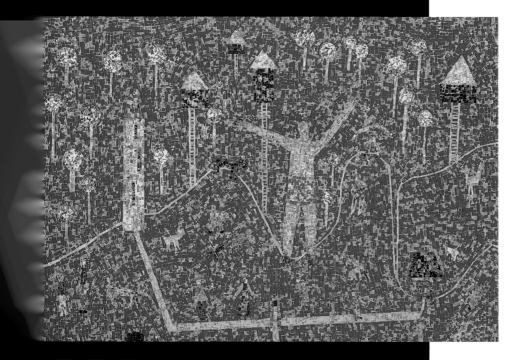

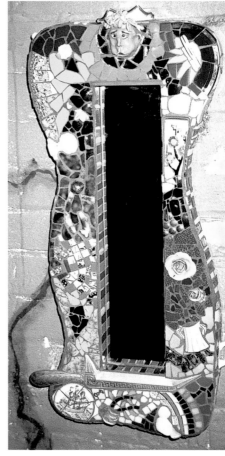

Above left: Paul Edlin, *Giant Among Friends*, 1994. Postage stamps on paperboard, 16 x 20 inches (40 x 50 cm). *Courtesy of American Primitive Gallery, New York.*

Left: Martha Neaves, *Woman with Red Cup*, 1998. Vitreous glass, 18 x 13 inches (45 x 32.5 cm).

Above right: Joe DiFiore, *Celery Head*, 1998. Mixed media, tile, china, found objects, glass. *Courtesy of Michelle Petno at Wits End Mosaics, Orlando, Florida.*

Right: Tessa Hunkin, *Louise Woodward*, 1997. Glass, 26 x 26 inches (65 x 65 cm). *Photo by Shona Wood.*

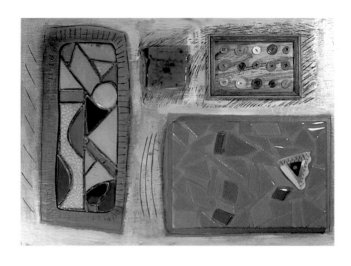

Above left: Jeri Burdick, *Tile Sampler*, 1998. Mixed media, 30 x 30 inches (75 x 75 cm). *Photo by Kitty Parrot.*

Top right: Al Hansen, *She Said Meet Me in East Orange*, 1986. Hershey wrappers, paper mounted on board, 15¼ x 11½ inches (38 x 28.7 cm). *Courtesy of Gracie Mansion Gallery, New York.*

Left: Tessa Hunkin, *Progress*, 1995. Glass, 24 x 40 inches (60 x 100 cm). *Photo by Shona Wood.*

Right: Tessa Hunkin, *Centurion*, 1995. Glass, 12 x 24 inches (30 x 60 cm).

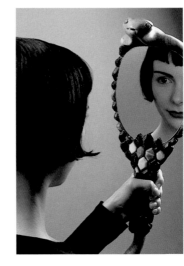

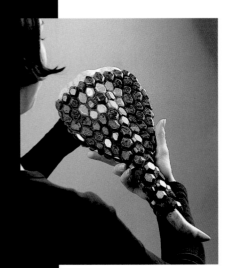

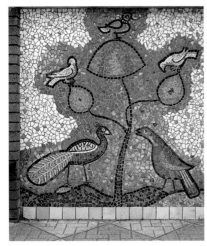

Above: Martin Cheek, *Leaping Salmon,* 1997. Vitreous glass on steel plate, 59 x 42 inches (148 x 106 cm). *Photo by Martin Cheek.*

Above right: Kenny Young, *Marble and Alabaster Snake Hand Mirror,* 1999. Marble, alabaster, glass, and paint. 19¾ x 6½ x ¾ inches (49.3 x 16.2 x 1.8 cm).

Center right: Elaine M. Goodwin, *Animal Farm,* 1994. Recycled materials, broken china, tiles, and other media, 33 x 6.6 feet (10 x 2 m). *Walter Daw School, Exeter, England. Photo by John Melville*

Right: Elaine M. Goodwin, *Preliminario. I,* 1998. Marble, Venetian glass, granite, metals, 20 x 20 inches (50 x 50 cm). *Photo by John Melville.*

Left above: Rosalind Waites, *Mosaic Mackerel* (submerged at high tide), 1996. Found pebbles, shells, and broken glass, 55½ ' (5m) long. *Lochmaddy, North Uist, Outer Hebrides, Scotland*

Left below: Elaine M. Goodwin, Mary Arches (city mural), 1991. *Interpretation of a 16th century map*, recycled materials, black and white china, 42 sq. yards (35 sq. m.). *Exeter, England. Photo by John Melville.*

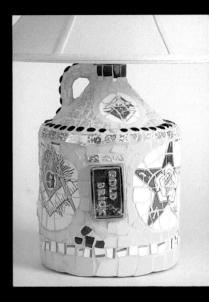

Right: Terry Taylor, *Masonic Lamp*, 1998. Plates and mixed media, 16 inches (40 cm) tall. *Photo by Evan Bracken.*

Right below: Benjamin Wedel, Hermes Sundance Collection, 1998. Quartz crystal, opalescent stained glass, and antique silver samovar, tray, and miscellaneous serving pieces .

Right below: Benjamin Wedel,

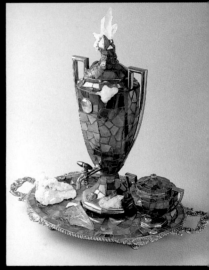

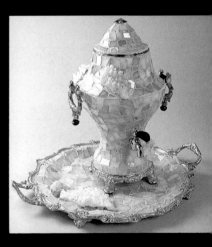

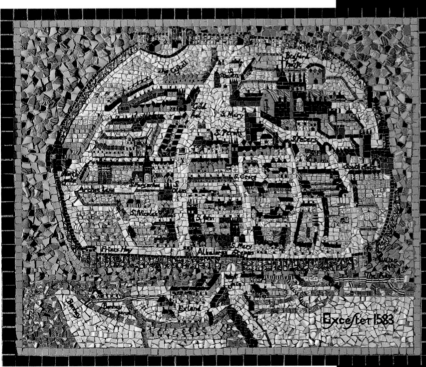

Above left: Sonia King, *Pinnacle,* 1999. Vitreous glass tile, 11 x 16 inches (28 x 40 cm). *Photo by Expert Imaging, Dallas, Texas.*

Left: Sonia King, *Wave,* 1999. Ceramic, vitreous glass, 12 x 16 x 3 inches (30 x 40 x 8 cm). *Photo by Expert Imaging, Dallas Texas.*

Below left: Jeni Stewart-Smith, *detail from the series Hawks,* 1984. Vitreous glass, 1½ x 1½ feet (45 x 45 cm) detail, 3 x 2 feet (90 x 60 cm) series.

Above right: Sherri Warner Hunter, *Love So Blue,* 1997. Soda cans, broken plates, wood, metal, 22 x 22 x 3 inches (55 x 55 x 7.5 cm). *Photo by Scott Thomas.*

Right: Lilli Ann Killen Rosenberg, *Frog,* 1997. Concrete, found objects, ceramic tile and pieces, 2½ x 5 feet (30 x 150 cm). *St. Christopher's Childrens Hospital, Philadelphia. Photo by Claire Van der Zwan.*

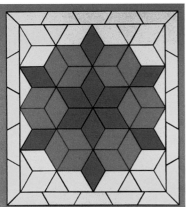

Left: Sven Warner, *Fire/Light,* 1994. Color-tex (fabric), 36 x 48 inches (90 x 120 cm).

Left: Sven Warner, *Red and Blue Rose,* 1994. Color-tex (fabric), 36 x 40 inches (90 x 100 cm).

Left below: Sven Warner, *Raisa Gorbachev,* 1993. Color-tex (fabric), 58 x 76 inches (145 x 190 cm).

Right: Emma Biggs, *Library Shower,* 1994. Glass. *Photo by June Buck.*

Right below: Jane Muir, *Marine Roundel,* 1998. Smalti, gold leaf, glass fusions, vitreous glass, 21¼ inch diameter (53 cm).

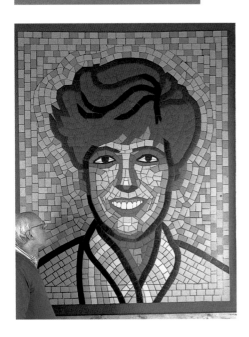

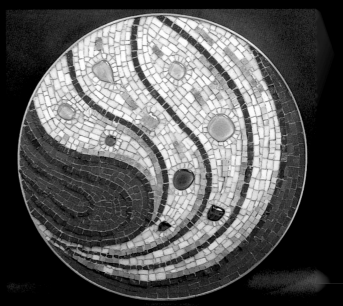

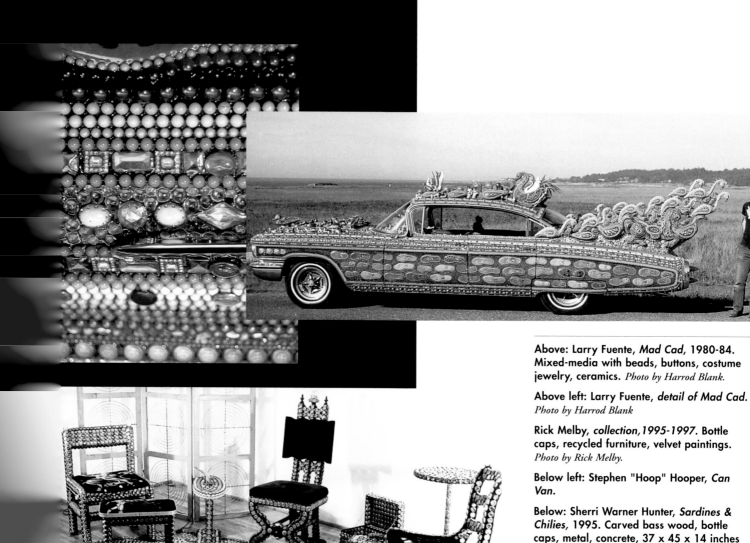

Above: Larry Fuente, *Mad Cad*, 1980-84. Mixed-media with beads, buttons, costume jewelry, ceramics. *Photo by Harrod Blank.*

Above left: Larry Fuente, *detail of Mad Cad.* *Photo by Harrod Blank*

Rick Melby, *collection,* 1995-1997. Bottle caps, recycled furniture, velvet paintings. *Photo by Rick Melby.*

Below left: Stephen "Hoop" Hooper, *Can Van.*

Below: Sherri Warner Hunter, *Sardines & Chilies,* 1995. Carved bass wood, bottle caps, metal, concrete, 37 x 45 x 14 inches (93 x 113 x 35 cm). *Photo by Scott Thomas.*

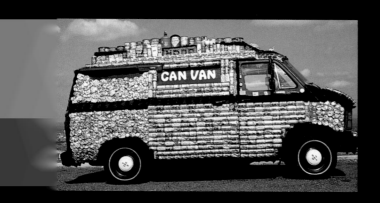

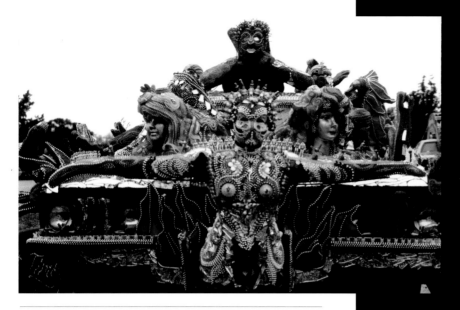

Above: Belleair High School art students under the direction of Rebecca Bass, *Hot Time Summer in the City* art car, 1998. Beads, trinkets, toys, mirrors, foam, synthetic stucco. *Photo by Carol Gunn. Courtesy of Penny Smith and Art Cars in Cyberspace.*

Above right: Harrod Blank, *Flash Suit*, 1998. A 67 pound suit covered with 2,000 flash cubes, plus magic cubes, plastic price tags, and adhesive. *Photo by Russel Faulkingham.*

Right: *Gene Pool, Cork Suit*, 1994-99. 4200 wine bottle and champagne corks, eye screws, 62 lbs (28 kg). *Photo by Harrod Blank.*

Below: Harrod Blank, *Camera Van*, 1995. Assortment of 2,000 cameras (including 10 functioning units), rivets, self-taping sheet metal screws, silicone caulk. *Photo by Harrod Blank.*

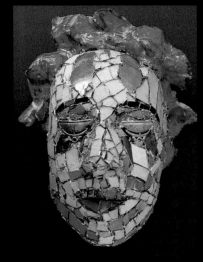

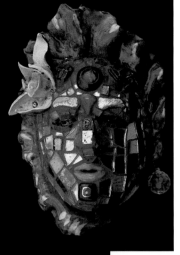

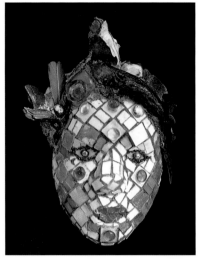

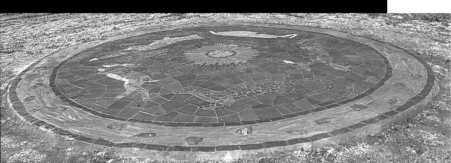

Above left: Janet Kozachek, *Endymion I,* 1998. Found objects, ceramic, glass, 6 x 12 inches (15 x 30 cm). *Photo by Janet Kozachek.*

Above center: Janet Kozachek, *Narcissus,* 1998, Crystal, mirrored glass, ceramic, 8 x 15 inches (20 x 37.5 cm). *Photo by Janet Kozachek.*

Above right: Janet Kozachek, *Wedding Mask,* 1998. Smalti, gold, fused glass, wood, 7 x 18 inches (17.5 x 45 cm). *Photo by Janet Kozachek.*

Center: Rosalind Wates, *detail of Grizedale,* 1992. Natural stone, slate, reject roofing tiles, mortar, 19¾ inches (6 m) diameter. *Grizedale Sculpture Park, Cumbria, England.*

Center right: Rosalind Wates, *detail of Grizedale,* 1992. Welsh slate, reject roofing tiles, mortar, 19¾ inches (6 m) diameter. *Grizedale Sculpture Park, Cumbria, England.*

Center left: Rosalind Wates, *Grizedale,* 1992. Natural stone, slate, reject roofing tiles, mortar, 19¾ inches (6 m) diameter. *Grizedale Sculpture Park, Cumbria, England.*

Right: Glen Michaels, *Moon Crater,* 1974. Assembled and cast bronze, 5½ x 5½ feet (1.7 x 1.7 m). *Spokane World's Fair Expo, Spokane, Washington.*

Right: Glen Michaels, *detail of Moon Crater,* 1974. Assembled and cast bronze, 5½ x 5½ feet (1.7 x 1.7 m). *Spokane World's Fair Expo, Spokane, Washington.*

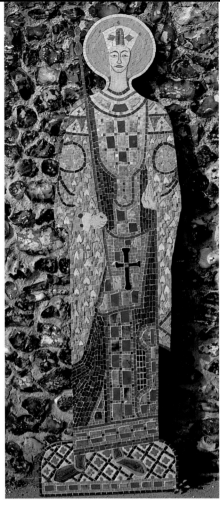

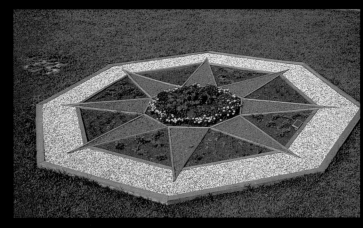

Top left: Martin Cheek, *Ordelaffo Falier-St. Mark's Saint,* 1998. Colored and gold smalti, raku-fired pieces, 72 x 21 inches (180 x 54 cm). *Photo by Martin Cheek.*

Top right: Norma Bradley, *Free Flight,* 1991. Wood, river rock, vegetation, 1 x 25 x 25 feet (2.5 x 62 x 62 cm). *Anderson Elementary School, Bayboro, North Carolina.*

Above center left and right: Norma Vondee, *Water Feature,*1998. Metal mesh, stoneware tiles, vitreous glass, white gold, 40 x 30 inches (100 cm x 75 cm).

Right: Norma Vondee

Above left: Toby Mason, *Forming of the World,* 1998. Wood, colored mirror, stones, 21 x 28 inches (53 x 70 cm). *Photo by Toby Mason.*

Above right: Toby Mason, *The Water Galaxy,* 1999. Wood, colored mirror, stones, 22 x 31 inches (55 x 78 cm). *Photo by Toby Mason.*

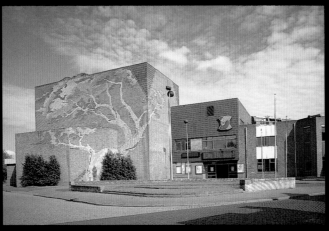

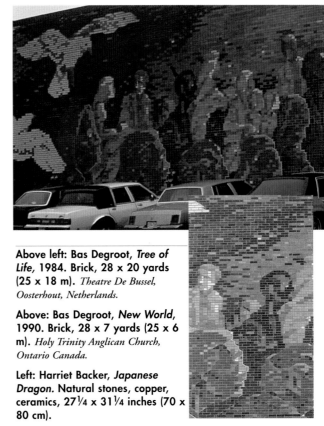

Above left: Bas Degroot, *Tree of Life,* 1984. Brick, 28 x 20 yards (25 x 18 m). *Theatre De Bussel, Oosterhout, Netherlands.*

Above: Bas Degroot, *New World,* 1990. Brick, 28 x 7 yards (25 x 6 m). *Holy Trinity Anglican Church, Ontario Canada.*

Left: Harriet Backer, *Japanese Dragon.* Natural stones, copper, ceramics, 27¼ x 31¼ inches (70 x 80 cm).

Below left: Sonia King, *Primeval,* 1998. Slate, ceramic tile, marble, and fossils, 14¼ x 20 x 1½ inches (36 x 50 x 4 cm). *Photo by Expert Imaging, Dallas, Texas.*

Below: Lilli Ann Killen Rosenberg, *Trees,* 1989. Old saw blades, rocks, concrete, Italian ceramic tile, 5 x 8 feet (1.5 x 2.4 m). *Private collection, New York. Photo by Will Faller.*

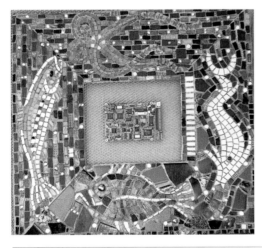

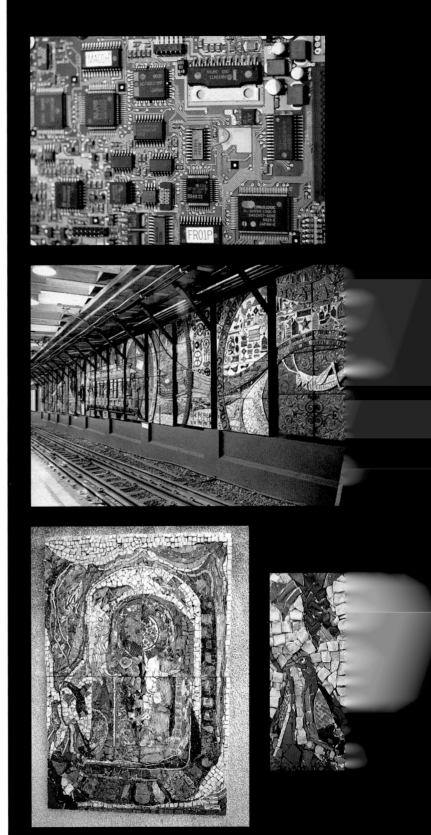

Above left: Norma Vondee, detail of *Fish and Chips.*

Center left: Norma Vondee, detail of *Fish and Chips.*

Below left: Norma Vondee, *Fish and Chips,* 1997. Aluminum honeycomb, antique venetian smalti, earthenware tiles, vitreous glass tiles, mirror screws, chain, circuitboard, 40 x 36 inches (100 x 90 cm).

Above right: Norma Vondee, detail of *Fish and Chips.*

Center right: Lilli Ann Killen Rosenberg, *Celebration of the Underground,* 1978. Found objects, train parts, ceramic tile, concrete, 10 x 110 feet (3 x 33 m) *Park Street Subway Station, Boston (the first subway station in the United States). Photo by Ken Wittenberg.*

Below right: Ilana Shafir, *The Big Gate.* Gold smalti, mixed stone, shells, corals, broken ceramic, 32 x 48 inches (80 x 120 cm). *Photo by Giora Shafir.*

CONTRIBUTING DESIGNERS

KATE BREWER FISHER lives in Asheville, NC, where she teaches in the Asheville Art Museum's Literacy Through Art program. When not working with her students, she creates functional art from found materials, exhibiting and selling her creations in local galleries and shops.

EVANS CARTER is a college student living in Asheville, NC. Self-described as a "Jane-of-all-trades," she enjoys working with metal, wood, stone, glass, paint, and just about any other medium you can name.

NICK CAVE, in collaboration with his partner Jeffery Roberts, creates cutting edge, one-of-a-kind, and limited edition handpainted items for Robave, Inc., their Chicago-based fashion and design company. For more information on their gorgeous, unusual, and high-quality fabrics, fashions, and furniture, contact Robave, Inc., 1313 S. Michigan Ave., 5th floor, Chicago, Illinois, 60605, (312)461-0400. Or e-mail: robave@msn.com.

PERRI CRUTCHER developed his flare for shaping flowers into artistic creations while working as a floral designer in Paris and New York. He now creates from within his own floral design studio, Perri Ltd., in Asheville, NC, where he shares his passion for flowers and the arts through workshops, exhibitions, and stunning sidewalk displays.

BARBARA COX made her living collecting and selling antique perfume bottles and estate jewelry until she discovered that, with a little glue and an assortment of pearls and beads, she could transform these items into new fashion objects. She sells her dresser sets, baskets, and vintage hats in antique stores and vintage shops throughout the U.S.; her beaded accessories are also available through her business, Cox Fashions, Box 18 Glenview Road Arden, NC 28704, (828) 684-5503.

CATHERINE DELGADO is a Florida-based mosaic artist who mixes stained glass, stone, and marble to turn functional pieces into eye-pleasing objects for home decor. In addition to showing her works at fine art festivals across South Florida, she sells them in gift shops in the U.S. and abroad. Her mosaicked pieces can also be seen on her website at www.MosaiqueArt.com., or contact her at Mè Mosaïque, 10023 Twin Lakes Drive, Coral Springs, FLA, 33071, (888) 431-4445.

TONI FURBRINGER-Long is a psychotherapist who uses art—specifically painting and journaling—to promote self-expression as part of her clients' therapy. She finds and puts pieces together through her practice, and her personal mosaics are inspired by the memories and hopes expressed by her clients. Mosaics offer her an opportunity to see a variety of rich textures and colors come together as a complete product.

DANA IRWIN lives in Asheville, NC, and is an art director for Lark Books. Both on and off the job, she designs and makes wonderfully imaginative books, posters, and artworks of all kinds.

SUE L'HOMMEDIEU lives outside of Cleveland, OH, where she is a stay-at-home mom with two teenage sons. As her children grew, she took advantage of her expanding free time by exploring her interests in gardening, crafting, freelance writing, and photography. She is an avid gardener during the summer months, and devotes her indoor time during the long winter months to projects that combine dried flowers, paper art, and mosaics.

ANN MCCLOSKEY works in many media and has a fondness for mixing them. She loves to create and experiment with new and old materials. She enjoys changing old flea market items into wonderful new designs. Her work may be found in many books and magazines. Ann lives in Copley, OH.

TAMARA MILLER is a mom first and crafter second who lives in Hendersonville, NC, with her husband, Jeff, and son, Beck. She is especially motivated by projects that allow her to incorporate the interests of her family while utilizing her creativity.

JEAN TOMASO MOORE can craft anything she sets her mind to, but is especially talented in using multimedia decoupage techniques and adapting those techniques to make unusual mosaics. She lives and creates in Asheville, North Carolina.

LINDA ROSE NALL has worked with stained glass for 10 years. She designs and produces one-of-a-kind functional pieces for Silver Rose Rhapsodies, including mosaics, incense burners, candle holders, wine and champagne glasses, jewelry, and more. Her work can be found throughout western North Carolina and on her website at www.Brwm.org./rhapsodies. E-mail her at rhapsodies@worldnet.att.net.

MICHELLE PETNO stumbled upon her success as a mosaic artist after customers began to inquire about the mosaic embellishments she had made to the interior of her used furniture shop in Orlando, Florida. She has since focused entirely on making mosaics and now teaches classes on using tile and glass beads to decorate furniture and found objects from her transformed business, Wits End Mosaics, 5224 West State Road 46, Suite 134, Sanford, FLA, 32771. She also sells mosaic supplies through her website at www.mosaic-witsend.com.

SANDI AND BRIAN PRICE are both architects living near Asheville, North Carolina's historic Montford district. Currently renovating their circa-1926 brick home, they created a mosaic birdbath to accent an in-the-works cottage garden of vegetables, herbs, and flowers.

CAROLYN POTTER is a polymer clay artist whose interest developed from earlier experimentation with ceramic clay techniques. Polymer clay allows her to experiment with color and designs as no other media she has worked with, and she especially appreciates the way canework, with its patterns of color, embellishes her sculptural artwork.

LAURA ROBERSON lives in Philadelphia, where she is a graduate student of textile design at the Philadelphia College of Textiles and Science.

PAT SAMUELS draws her inspiration for mosaics from her fascination with ethnic textiles, molas, and quiltmaking. She teaches creative classes for children and adults and has a studio in Fairview, NC.

HEATHER SMITH hails originally from the coast of Maine, where in recent years she has taught a variety of environmental education programs. These days, she makes her home in Asheville, NC, where she is an assistant editor at Lark Books and enjoys crafting, biking, and hiking in the western NC mountains.

TERRY TAYLOR lends his creative spirit full-time to the Lark Books catalog, and in his spare time glues, pastes, and otherwise assembles works of art using a wide range of media from old CDs to broken china. He occasionally exhibits his works, and his designs have been featured in numerous publications.

NICOLE TUGGLE uses a variety of paper craft techniques to create unique cards and gift items. She uses her art as a means of communication, emotional release, and as a celebration of the simple act of giving. She currently resides in Asheville, NC, where she is waiting for her true passion to fall from the sky and bonk her on the head.

SVEN WARNER (see Gallery Artists)

SHERRI WARNER HUNTER (see Gallery Artists)

ELLEN ZAHOREC is a mixed-media artist who works out of her Cincinnati, OH, studio. She specializes in works incorporating handmade paper and collage. Her work has been exhibited internationally and is included in many private and corporate collections.

GALLERY ARTISTS

HARRIET BACKER has been hunting and gathering natural stones from Greenland to Egypt for use in mosaic assemblages since the 1960s. Her public and private commissions are cherished throughout Europe, where she often travels for her projects while maintaining her studio at Heyerdahlsrei 18, 0386 Oslo, Norway.

HARROD BLANK merged his fascination with art cars, and filmmaking and photography savvy, to create the documentaries Wild Wheels and Driving the Dream. His mosaicked "Camera Van" serves as his recording vehicle, with 10 working cameras affixed among more than one thousand decorative units. Contact him at www.Cameravan.com. Write to excentrix@aol.com or 2248 Summer Street, Berkeley, CA 94709.

NORMA BRADLEY'S Earth Quilts unite local people and natural materials to foster community expression and celebration. She has sewn the seeds for Earth Quilts in communities across NC and can be contacted at (828) 252-6460, 16 Albemarle Road, Asheville, NC 28801.

JERI BURDICK has been a studio clay artist for 17 years. She designs and produces two- and three- dimensional mixed-media art, using clay as her springboard medium. She exhibits her work throughout the Southeast, primarily at Blue Spiral Gallery, Asheville, NC; Carol Saunders Gallery, Columbia, SC; and Nina Liu Gallery, Charleston, SC.

MARTIN CHEEK Mosaics are a natural extension of Martin Cheek's experience with animation, both requiring the construction of a coherent whole from thousands of individual parts. His mosaic designs have been featured in numerous galleries across the UK, and in several publications. He has recently authored two books published by New Holland Publishers of London. Contact him ontacted at: www.mosaicart-cheek.demon.co.uk. or at Flint House, 21 Harbour Street, Broadstairs, Kent CT10 1ET, England,

BAS DEGROOT makes wonderful use of a variety of techniques and materials, including drawing, painting, sculpting, mosaics, and stained glass to express his ideas through his art, which is exhibited around the world. His large-scale brick mosaics, some using over 20,000 bricks, are on permanent display in The Netherlands, Canada, and the United States. P.O. Box 482, Port Colborne, Ontario L3K 5X7, Canada. http://www.cats.on.ca/cats/degroot.htm. Or e-mail: degroot@itcanada.com

JOE DIFIORE has ventured out of the realm of traditional tile mosaics, preferring to experiment with found objects, broken bits, and memory pieces. His functional mosaic pieces are on display at Wit's End Mosaics in Orlando, Florida, or write to 204 N. Tremain Street, Mt. Dora, Florida 32757.

GARY DROSTLE AND ROB TURNER

As partners, Drostle and Turner combine their individual strengths to produce public art murals incorporating mosaics and painting. For the Doncaster Community Arts Centre commission, they hosted a poetry workshop to involve local people in the creation of a design that would reflect their history. Each panel in their work included in this book portrays a layer of time and corresponding objects as would be uncovered in an archeological dig, and the shadow suggests the memory of those who have passed before. Wallscapes, 11 Ennis Road, London SE18 2 QR, England

e-mail: mosaics@wallscapes.ndirect.co.uk

PAUL EDLIN left behind a career of clerical work 20 years ago, and has since focused on constructing intricate mosaics from everyday postage stamps. He sees elements of color, shapes, and possibilities in the cut-up letters and images he manipulates to create his unusual works of art. His pieces are on exhibition with the American Primitive Gallery, 594 Broadway, #205, New York, NY 10012.

LARRY FUENTE'S mixed-media art work has adorned the covers of international magazines including National Geographic and Time, and is featured in Smithsonian's Renwick Gallery of the National Museum of American Art. He transforms common findings and trinkets, from beads to glass baubles, into the unusual by combining them as surface decoration atop simple, identifiable forms. P.O. Box 954, Mendocino, CA 95460

ELAINE GOODWIN is a master mosaicist and author based in England, who exhibits her works in museums and galleries worldwide. In addition to producing community murals and individual works of mosaic art, she is president of the British Association for Modern Mosaics and a member of The International Association of Contemporary Mosaicists. She is also an active

promoter and instructor of the art of mosaics, and hosts an annual summer workshop, held in London, for mosaicists of all levels. Elaine Goodwin Mosaics, 4 Devonshire Place, Exeter EX4 6JA, England; phone/fax: 01392 270943.

AL HANSEN has worked extensively as an artist and teacher in the United States and Europe since the 1960s. His rich and always cutting-edge works have been featured in galleries from New York to Munich to Tokyo. Some of his work is available through the Gracie Mansion Gallery, 54 Saint Marks Place, New York, NY 10003. (212) 505-7055

STEVEN "HOOP" HOOPER puts a monumentally new spin on old wheels, creating fun, flamboyant art cars exhibited in numerous museums and well known to hangers-out in New York City's East Village and Soho neighborhoods and the South Bronx.

TESSA HUNKIN AND EMMA BIGGS combined their talents to form the Mosaic Workshop more than ten years ago, and have continued to make strong, colorful mosaics in glass, marble, smalti, and ceramic for exhibition throughout Europe and in myriad magazines and books. They share their expertise with others through classes at Mosaic Workshop, Unit B, 443-9 Holloway Road, London N7 6LJ, United Kingdom, 0171 263 2997 phone/fax.

SHERRI WARNER HUNTER collects and manipulates found objects and materials from Tennessee's interstate roadsides to create intriguing and eccentric works of art. She has begun to focus on large-scale public sculptures, while continuing to exhibit her award-winning mixed-media artwork throughout the mid-South. She can be contacted at 3375 Fairfield Pike, Bell Buckle, Tennessee 37020.

SONIA KING'S first contact with mosaics was as a child when her mother worked in the medium. She has built upon this background through extensive global travel, examining ancient mosaic sites and studying with contemporary mosaicists. Contact her at: WhateverWerks, 1023 Sarasota Circle, Dallas, Texas 75223; e-mail to: whateverwerks@ibm.net.

JANET KOZACHEK'S work using rare and precious objects like arrow heads, stoneware shards, and gemstones has been exhibited in galleries in the U.S., China, and The Netherlands. She is represented by the Portfolio Gallery, Columbia, South Carolina; Touchstone Gallery, Hendersonville, North Carolina; The Mint Julep Gallery, Grapevine, Texas; and Nina Liu Gallery, Charleston, South Carolina. Contact her at 639 Wilson Street, NE, Orangeburg, South Carolina 29115.

TOBY MASON considers himself a painter beholden with a palette of colored mirror and stone. After a successful stint as a stained glass artist, he began experimenting with mosaic techniques to utilize the shards of glass, colored mirror, and stone slivers that have since become synonymous with his art work. Contact him at Reflective Glass Mosaics, 911 Country Club Drive, Vienna, VA 22180-3621; website: www.erols.com/masont; phone: (703) 242-2223.

RICK MELBY reuses found objects to make one-of-a-kind pieces of functional art. His work has been exhibited and collected internationally. He resides at 37 Biltmore Avenue, Asheville, North Carolina 28801, (828) 232-0905.

GLEN MICHAELS, a painter and mosaic artist, has been assembling abstract multi-dimensional murals and sculptures since the 1960s, experimenting primarily with metals, tile, plastics, and wood. He has designed commissions for corporations, public buildings, and private collections throughout the U.S. Featured in Who's Who of American Art, he is the recipient of numerous grants and awards, and has participated in several exhibitions at the Museum of Contemporary Crafts in New York. Contact him at 4800 Beach Road, Troy, Michigan, 48098.

JANE MUIR— inspired by weathered rocks, mythical animals, and the sea, and influenced by Botticelli, Rembrandt, Tapies, and Paul Klee—creates abstract mosaic compositions exploring color, structure, texture, and reflected light. A mosaicist since 1969, she has produced a number of public

and private commissions across the UK. In addition to mosaics, she produces her own body of etchings and paintings from her studio: Butcher's Orchard, Main Street, Weston Turville, Aylesbury Bucks HP22 5 RL, United Kingdom.

MARTHA NEAVES is a ceramic artist and teacher who in recent years has been drawn to mosaic art. She enjoys manipulating pieces of vitreous glass and allowing the mosaic material to lead her through the building processs. She now balances her demands as a full-time mother with her desire to be creating from her home studio, Yadkin River Studios, 219 Surry Avenue, Elkin, North Carolina 28621.

GENE POOL is probably best known for his live grass suits and cars, which caught the attention of former late-night talk show host Johnny Carson, but he has also turned corks, coins, feathers, light bulbs, and keys into wearable art. Along with television performances, Pool and his ingenious suits have appeared in feature films (including David Byrne's True Stories, 1988), books, and advertising campaigns in both the U.S. and Europe. Contact him at 151 First Avenue, #6, New York, New York, 10003, by phone at (718) 486-8386.

LILLI ANN KILLEN ROSENBERG draws on her training in architecture, sculpture, and ceramics to design community murals and art projects from clay and mosaics. She works closely with her husband, Marvin, and together they attempt to design projects with the goal of enhancing the quality of life in participating communities through the creation of art with and for the people. 4001 Little Applegate Road, Jacksonville, Oregon, 97530, United States.

JOHN SALVEST exhibits his work with the New Museum of Contemporary Art, 583 Broadway, New York, New York, (212) 219-1222.

ILANA SHAFIR approaches her mosaic palette of stones, smalti, corals, shells, glass, and ceramic with an open mind for spontaneous creation. As an artist and teacher, she shares her open studio with the Ashkelon community and often incorporates a neighbor's broken china into her mosaics. Contact her at: 2 Kapstadt Street, Afridar 78406, Ashkelon, Israel, 011-972-7-673-2879; or in the U.S., through Leah Zahavi, 150 North 9th Avenue, Highland Park, New Jersey 08904, (732) 572-7368.

JENI STEWART-SMITH has worked as a private commission artist for over 30 years. She uses mostly traditional materials in a contemporary and functional fashion. Contact her at 24 Carneton Close, Crantock, Nequay, Cornwall TR8 5RY, England.

TERRY TAYLOR lends his creative spirit full-time to the Lark Books catalog, and in his spare time glues, pastes, and otherwise assembles works of art using a wide range of media from old CDs to broken china. He occasionally exhibits his works, and his designs have been featured in numerous publications. 67 Broadway Avenue, Asheville, North Carolina 28801.

NORMA VONDEE is a London-based mosaic artist who devotes much of her time to organizing and teaching mosaic related workshops. Fascinated by fluid forms and images, she enjoys sculpting her mosaic creations to emit these elements of liquidity. She cohosts The London Mosaic Weekend for those who want to learn more or hone their mosaic skills with accomplished artists in the field. Write to 8 Benson Quay, London E1 9TR, England, (171) 481 4563.

SVEN WARNER has been experimenting with mosaics since the 1970s, with a particular emphasis on expressing personal meaning through geometric pattern work and portraiture. In the 1990s, he has concentrated on teaching and developing beginner-friendly materials for making mosaics, including the cast-tile material he now markets as "Fractile" and "Sniptile." Discouraged by the limited availability of certain materials, he started Mountaintop Mosaics in 1995 to provide supplies and advice to mosaicists across the United States. He also hosts workshops and can be contacted at Mountaintop Mosaics, P.O. Box 653, Castleton, Vermont 05735, (800) 564-4980, and via the internet at www.mountaintopmosaics.com.

ROSALIND WATES was trained in decorative arts at The City and Guilds of London Art School and has since specialized in mosaics. Her more recent endeavors have involved producing public art commissions that exult the essence of the selected area's natural environment through the use of found stone, shells, and other organic materials. Contact her at Malberet, Bar Lane, Owlswick, Princes Risborough, Buckinghamshire, HP27 9RG, U.K. Or e-mail: rosalind.wates@mosaics.demon.co.uk.

BEN WEDEL works in many artistic media, most recently devoting his creative energies to making elegant and unusual mosaics for indoors and outdoors, allowing him to merge his gardening savoir-faire with his flair and skill for making mosaics. His works are shown and sold in galleries throughout the United States, and through his company Blue Rain (website: Bluerain/Fineart.com).

KENNY YOUNG is a Brooklyn-based artist who works in a a diverse range of media, with a focus on sculpting myriad types of stone and wood. His wonderfully unusual and thought-provoking works of art have been exhibited in galleries across the country

For additional information contact **Society of American Mosaic Artists P.O. Box 428 Orangburg, S.C. 29116**

INDEX